MASTERING

Hand-Lettering

DJGHQA
OKMBNE
CS

MASTERING

Hand-Lettering

DJGHQA CHMBNAe OKMBN CS

YOUR PRACTICAL GUIDE *to* CREATING *and* STYLING *the* ALPHABET

Mye De Leon

Skyhorse Publishing

Text and illustration copyright: © Mye De Leon 2017
Layout and design copyright: © BlueRed Press 2017
Design: Insight Design Concepts ltd

First published in 2017 under the title Mastering Hand-Lettering by
BlueRed Press.
First Skyhorse Publishing Edition 2017

Skyhorse Publishing books may be purchased in bulk at special
discounts for sales promotion, corporate gifts, fund-raising, or
educational purposes. Special editions can also be created to
specifications. For details, contact the Special Sales Department,
Skyhorse Publishing, 307 West 36th Street, 11th Floor, New York, NY
10018 or info@skyhorsepublishing.com.

Skyhorse® and Skyhorse Publishing® are registered trademarks of
Skyhorse Publishing, Inc.®, a Delaware corporation.

Visit our website at www.skyhorsepublishing.com.

10 9 8 7 6 5 4 3 2

Library of Congress Cataloging-in-Publication Data is available on file.

Cover design by Mye De Leon
Cover artwork: Mye De Leon
Back cover image ©Kristoffer Igan De Leon 2017

ISBN: 978-1-5107-2941-4

Printed in India

Contents

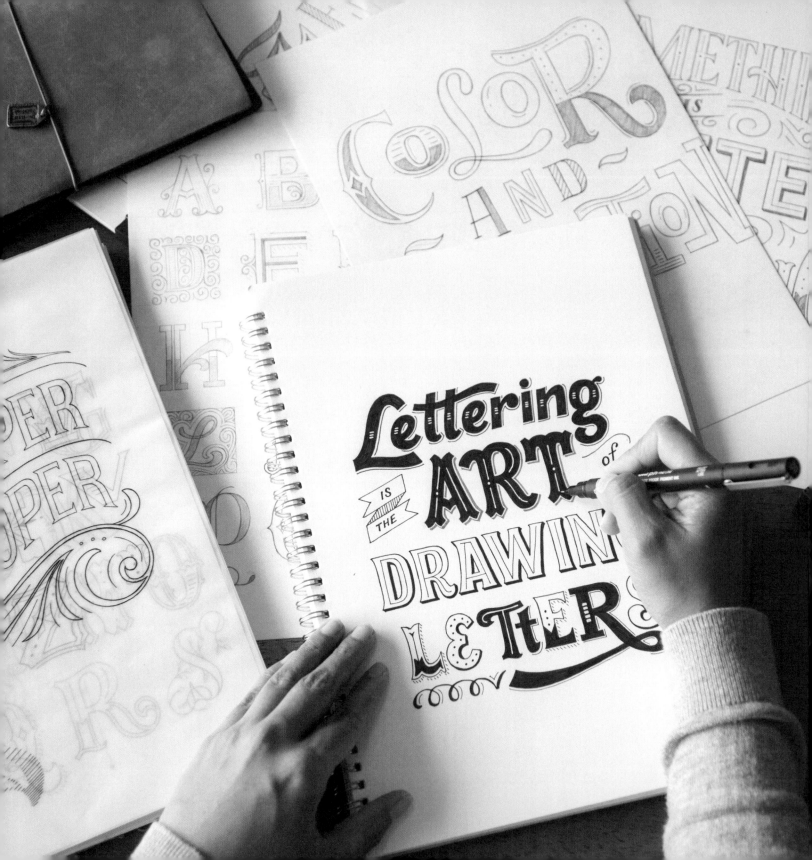

INTRODUCTION

Introduction

Hand-lettering has been around since writing began and was used for correspondence for thousands of years before technology introduced mechanical means to speed up the process. Over the years, hand-lettering has evolved into many different forms of communication, and it still inspires artists today. Thoughtful lettering turns simple messages into an elaborate, more memorable, and expressive form of communication.

Now, a bit about me: My name is Mye De Leon, and I was ten years old when I first learned about this art form, all thanks to a poster-making competition at school. While in high school, I taught myself to draw and decorate letters and, amazingly, my lettering skill helped me land a scholarship, and I'm proud to say my parents did not have to worry about my school fees. All because of lettering!

While studying at college, I helped my uncle in his screen-printing business and designed lots of political campaign material. Needless to say, I was working with letters without ever realizing it. After graduating I entered the corporate world and forgot about lettering for a time; I got married and had three children and left lettering behind for fifteen years. Then, in 2009, I stumbled upon digital scrapbooking—all the fun of memory-keeping minus the actual glue, paper, and mess. I taught myself Photoshop (essential for this new-found hobby) and started designing and selling my own products. When I returned to lettering, I delighted in holding a pencil again.

Every letter that I draw is an expression of what I am feeling at that moment. I already used Instagram and decided to share what I was drawing. I never realized that people loved letters that much! My following has grown, but that wasn't really my intention. I was there to just create and then share. I was approached to write books and in time established a freelance career—all based on lettering!

I am still learning about my art and view this as an essential part of my progress. I hope that I can ignite the same passion in you to pursue your love for letters. The guides in this book are based on my own process and learning experiences. Use them to inspire you in your journey to finding your own creative voice.

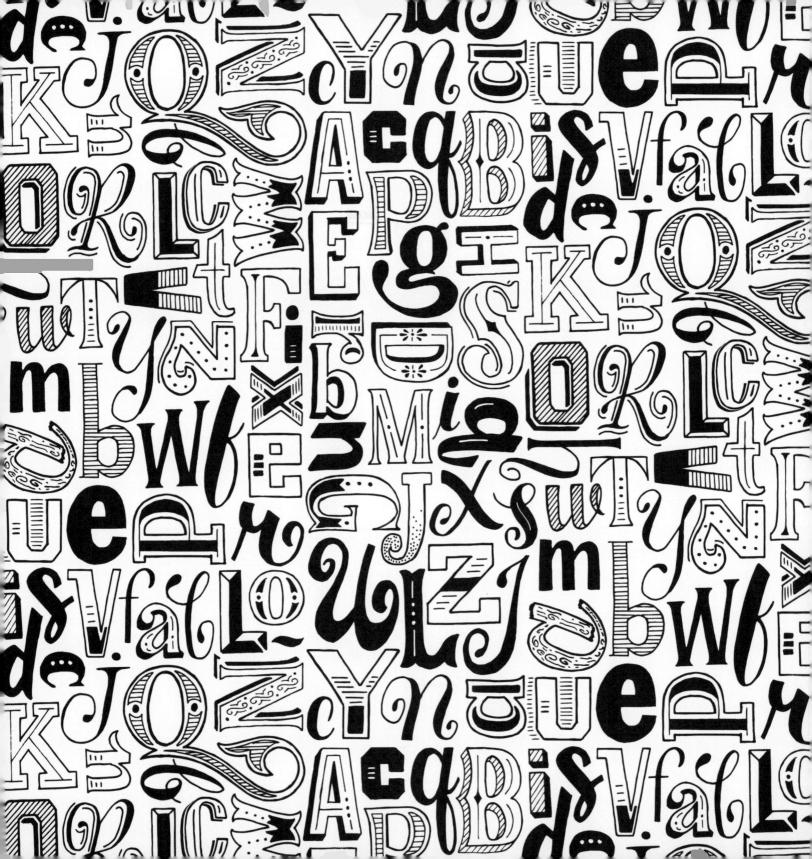

TERMINOLOGY

Definition of Terms

Lettering

Lettering is simply defined as the art of drawing letters. It is a totally different form of discipline and art form. In lettering, there is a multitude of ways to express an interpretation of a single letter and it is hand-drawn, fully customized, and intended for a single purpose only.

Typography

Typography

Typography is the art of arranging type to create a visually appealing content for print or publication. This arrangement involves picking typefaces, line lengths, point sizes, and adjustments on tracking, kerning, and leading. Type faces are designed for repeated use and therefore, each letter must be thoughtfully designed to complement the rest of the alphabet in whatever combination you need them to be to form your words. That's what makes it different from lettering.

Calligraphy

Calligraphy is the art of writing by execution of a broad tip instrument, typically a dip pen or a brush. It involves studying and mastering different strokes through drills in order to form letters and words. Needless to say, Calligraphy is a form of interpreting art in a skillful manner.

Type Terminologies

Kerning

Kerning is the adjustment of space in between letters. When letters are set too closed together, the words are harder to read so letters have to be spaced out appropriately for legibility. There is no exact mathematical component in terms of measuring the distance in between letters. Often, it is just a matter of eyeballing the areas that need adjustments.

Tracking

Tracking is not to be confused with kerning. While kerning involves spaces between letters, tracking involves adjusting the spaces throughout the entire word. It is used when there is a need to fill in a space that may be wider or smaller and is usually done after kerning has been set in place.

Leading

Leading is basically the spacing between the baselines. If you have multiple lines of texts, the distance between each lines must be spaced properly for it to be legible.

KERNING

LEADING

TRACKING

Anatomy of Type

Understanding the individuality of each letter of the alphabet gives a more personalized approach to drawing them. When you know their parts, you have a good knowledge of how you can manipulate and play with them to create more unique pieces of artwork. It's like knowing about your body parts and its functions. In lettering though, learning about the parts of the letter comes in handy when you need to discuss with a fellow designer or a client as it gives more specificity and avoids confusion.

- Slanted design styles are referred to as **italics** and **obliques**. Although they appear to be similar, they are actually different. **Obliques** are just the slanted version of a Roman weight while an **italic** is a totally different design. Most notably, the two-story letters a and g become single-story letters.
- Depending on the weight, letters can be **thin** or **bold** and would sometimes even have varying weights.
- When you change the width, you'll produce a **condensed** (narrow or compressed) or **wide** letter (extended)

Serifs
Serif comprises small features or a slight projection typically at the end of the main stroke of a letter.

Sans-Serif
A style that doesn't have any accents or strokes attached to its main part. Its literal translation is "without serifs" (from the French word **sans** meaning without), or "grotesque" (from the German word, **grotesk**)

Script
Script is based upon a variety of fluid stroke created by handwriting such as calligraphy.

Blackletter
Also referred to as Gothic or Old English, this style is highly recognizable because of its dramatic thick and thin strokes and sometimes elaborate serifs.

Dimensional

Dimensional lettering is created by exaggerating and/or projecting the shadows of your letters. This may vary depending on your light source and point of reference.

Dropcap

A drop cap or an initial is a large capital letter that is usually at the beginning of a text block. It is based on the Latin word, *initialis*, which means standing at the beginning and often has a fancy lettering style.

Ornate

These are highly decorated letters and often adorned with intricate details and ornaments.

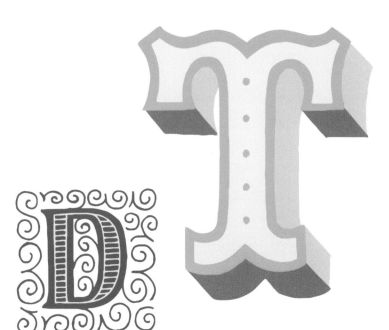

Illustrative

Illustrative lettering uses illustration for a more creative expression of conveying the message.

Combination

It is simply combining different lettering styles in a cohesive manner.

Chalk Lettering

Uses a chalkboard and chalk or chalkboard markers instead of the typical paper and pencil to draw letters.

REGULAR

Letters may vary depending on their style, weight and width

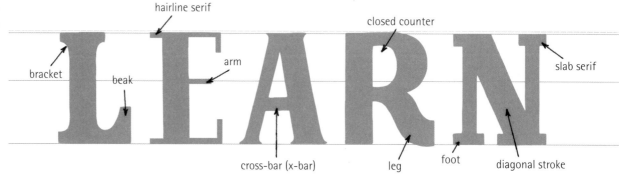

ITALIC

Slanted design styles are referred to as **italics** and **obliques**. Although they appear to be similar, they are actually different. **obliques** are just the slanted version of a Roman weight while an **italic** is a totally different design.

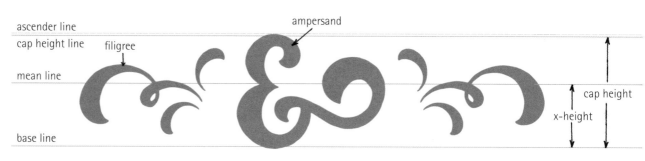

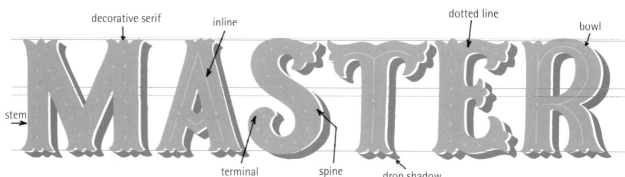

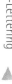

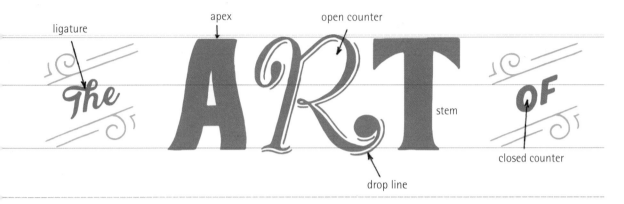

ligature

apex

open counter

stem

closed counter

drop line

serif

ascender

ball terminal

tittle

stroke

shoulder

ear

decorative inline

bilateral serif

spur

vertex

aperture

link

loop

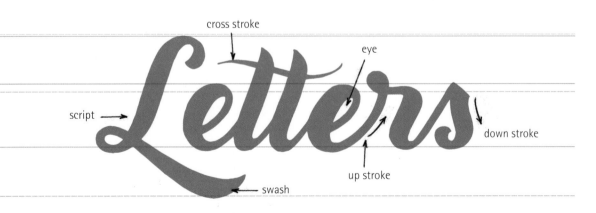

cross stroke

eye

script

down stroke

up stroke

swash

LIGHT
BOLD

Depending on the weight, letters can be thin or bold and would sometimes even have varying weights.

CONDENSED
WIDE

When you change the width, you'll produce a condensed (narrow or compressed) or wide letter (extended)

LETTERING TOOLS

Lettering doesn't require expensive tools. In fact, the most basic tools can be found at your local bookstores. You can begin with just a pencil, eraser, and regular bond paper. If you have cheap tools at your disposal, you will be able to create more freely because you don't have to worry about wasting expensive products if your artwork doesn't turn out well. Because lettering will require repetitive work, ordinary plain paper will come in handy for multiple trials and experimentations and I would personally encourage you to do just that. In time, you will find yourself wanting to create and explore more. Try different tools and mediums if you can. They will help you improve your craft and discover things that will be unique to you.

compass

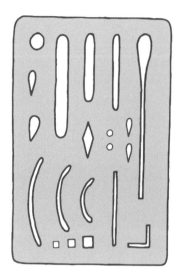

erasing shield

paper

tracing paper

ruler

triangle

mechanical pencil

pencil

fine-tip pen

parallel pen

nib pen

eraser

marker

sharpener

ink

brushes

DRAWING LETTERS

Now that we have discussed the basics of typography, we are going to explore the alphabet itself: how to properly draw each letter, giving every character the correct weight and shape. Although hand lettering is free form, there are still certain rules that you should know before you dive into the whole process of actually lettering. Understanding the nuances of every character will give you a better foundation for forming the letters and creating your own unique version of lettering.

Thin Stroke

Thick Stroke

UPSTROKE = thin stroke DOWNSTROKE **= thick stroke**

There are certain letters in the alphabet that are notoriously tricky to letter—M, R, and W are repeat offenders. This is primarily because of the lack of understanding about where the thick and thin strokes should be made. Over the following pages you will learn how to properly draw all the letters of the alphabet and how to form letters with correctly contrasting outlines by using a combination of thick and thin strokes.

The key to successful lettering lies in the process—so we will study the step-by-step procedure for each letter, carefully paying attention to every tiny detail.

Below are the lettering guidelines that are used throughout this exercise. Follow the drawing instructions and use the guides as a framework. Ascender lines and descender lines are used to draw lowercase letters.

ascender line

cap height line

x-height

mean line

base line

descender line

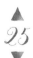

Uppercase Letters

Now that you understand the principles of typography, try to use them when drawing the first letter: A.

1. Following the guidelines below, draw the letter A at an angle from the baseline to the cap height, then diagonally back to the baseline.

2. Draw a horizontal stroke across the middle of the two **stems**. This horizontal stroke is also called a **crossbar**. This is the frame for your letter A or the **skeleton**. Everything starts from the skeleton.

3. When you've drawn the skeleton, slowly add weight to it. Remember, though, that in this lesson we are studying letters with contrasting strokes, so pay particular attention to the thickness of each stroke. In this case, because the first stroke is an **upstroke**, it is thinner than the the **downstroke**. The crossbar is a **horizontal** stroke, and therefore, a thin stroke. Alltogether this creates a sans-serif letter A.

bracketed serif →

bracket

1. letter frame 2. add weight 3. add serif

4. Once you've established the weight of your letter, you can add a serif. The most basic is a **hairline serif**, which in this case is a thin stroke drawn opposite the main stroke of the letter. You can either stick with the hairline serif or explore other potential serif options based on that stroke.

5. Now you can try adding brackets by drawing a tiny curve from the hairline serif to the stem, or vice versa. This new serif is called a **bracketed serif**.

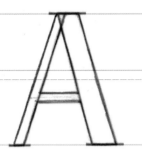
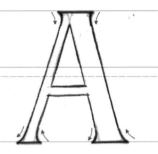

4. add a hairline serif

5. draw a curve from the main stem to the serif or vice versa

In this lesson, you've learned two types of serifs achieved by making a simple change to the strokes. These small details make up the style of the lettering. As we move on to drawing the entire alphabet, you will be shown two more serifs that you can create by leveraging the hairline serif.

Letter B has a **stem**, an **upper bowl**, and a **lower bowl**. Notice that this letter is not perfectly symmetrical. The lower bowl is typically bigger than the upper bowl and is slightly extended out to the right.

1. Draw the skeleton of your B by following the direction arrows of the strokes below. Pay particular attention to the size of the bowls and leave enough room to add weight or to thicken the strokes.

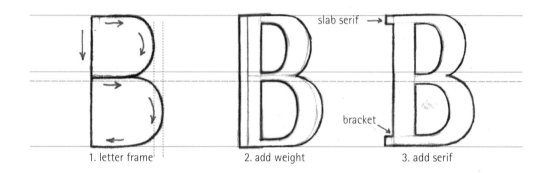

1. letter frame 2. add weight 3. add serif

2. Slowly add weight to the strokes by following the same direction arrows while keeping the downstrokes thick. Be careful to keep the lower bowl slightly extended.

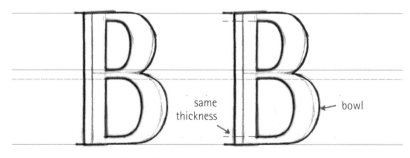

add a hairline serif

3. Once you've created your sans-serif B, you can add the hairline serif again and build another serif from there. Try to create an angular bracket to form a slab style. A **slab serif** is a block-like motif. When you're creating it, you need to pay attention to the thickness of the stroke on the opposite side, in this case the bowl of the B. The serif needs to have the same thickness as that of the bowl.

The letter C is a curve stroke. It has an **open counter** and a **finial**. A finial is the tapered or curved end at the bottom (or top) of the stroke. Letters that have curve strokes have to extend a bit above the cap height and slightly below the baseline. This slight extension of the stroke is called an **overshoot**. Following the strokes below, draw the skeleton of your C.

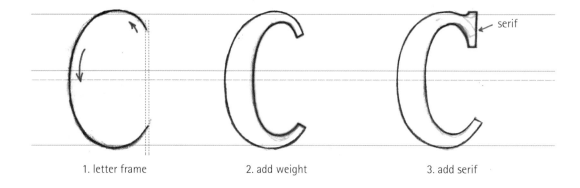

1. letter frame 2. add weight 3. add serif

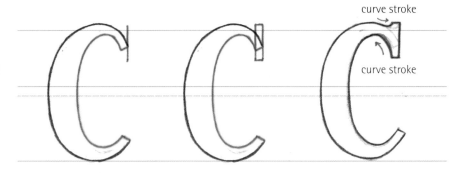

curve stroke

curve stroke

1. Adding weight to a curved letter is a little different because the strokes do not carry the same weight throughout. This is because in a curve stroke some areas have to be slightly tapered, especially when you're moving from an upstroke to a downstroke, or vice versa.

2. A serif can be added to a curve letter in various ways. One of the easiest is the basic hairline. Draw a small vertical stroke at the top of the letter, then immediately draw a curve and attach both strokes together to create a **bracketed serif**.

3. But what happens when you play with this style a bit? Let's duplicate that hairline stroke and close it to make a small rectangle. Now, we have a **slab serif**. Let's go further and add some tiny curve strokes at the top and bottom of the instroke. Now this has become a **slab-bracketed serif**.

Now that you are getting familiar with the method of drawing letters, let's move on to draw the skeleton of the D following the strokes below. This letter has a stem and a bowl. Next, remember how you added weight to B? Do the same to letter D.

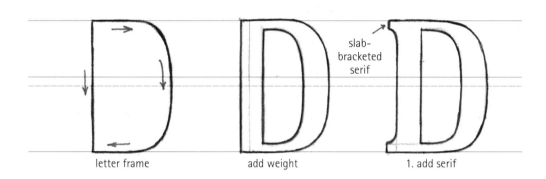

letter frame add weight 1. add serif

1. Create the same block-like serif extending beyond the stem of the D. From that slab serif, draw your bracket (curve stroke) connecting the serif and the stem as illustrated above.

The letter E has a stem and three **arms**. The middle arm typically lies above the mean line and must always be shorter than the other two arms.

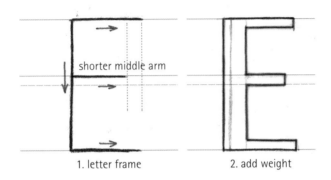

shorter middle arm

1. letter frame 2. add weight

1. Draw your letter E following the lines of the direction arrows.

2. Add weight to the letter using a thick stroke for the stem and thinner strokes for the arms.

3. Remember when I told you that your hairline serif should be drawn opposite the strokes of the letter? It applies to horizontal strokes, too. So draw a small stroke slightly extending from the stem and at the end of the arm.

4. For a bracketed serif draw a curved bracket from the hairline stroke to the stem. However, on an E, this can make the weight of the letter look awkward as the arms appear to be much thicker.

5. Now the thickness along the bracket and the arm is no longer in balance. The answer is a bracketed serif to even everything out. This means some readjusting is necessary, and in this case, the thickness of the arm stroke must be narrower where it is closer to the stem in order to balance the serif on the other side.

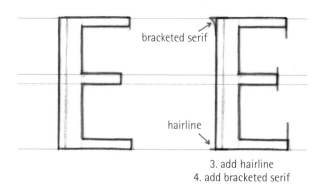

bracketed serif

hairline

3. add hairline
4. add bracketed serif

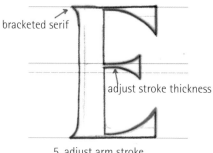

bracketed serif

adjust stroke thickness

5. adjust arm stroke thicknesses

Letter F looks similar to the letter E minus the lower arm. But, the shorter arm of the F is not resting above the mean line—it is **below** the mean line. This is to compensate visually for all the negative space at the bottom.

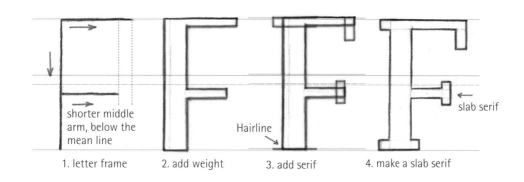

shorter middle arm, below the mean line

Hairline

slab serif

1. letter frame 2. add weight 3. add serif 4. make a slab serif

1. Draw your letter F.

2. Add weight to the letter (just as you did with E).

3. By this time, you should be familiar with the hairline serif, bracketed serif, slab serif, and slab-bracketed serif. Begin by adding a small hairline stroke at the stem and the arms of F.

4. Duplicate those strokes and close them up like a rectangle to make a slab serif.

G is another curve letter, so pay attention to its **overshoot**.

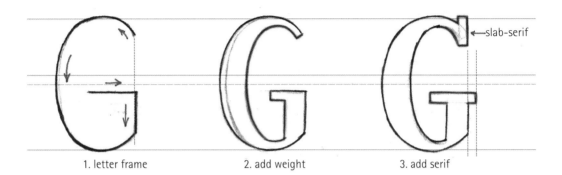

1. letter frame 2. add weight 3. add serif

1. Draw your letter G following the direction arrows.

2. Add a serif in the same way as you did with letter C, but this time do not add a curve stroke at the top edge of the main stroke.

3. Add a slab serif in the same way as you did with letter C, horizontally and vertically, without adding a curve stroke at the top slab where the main stroke begins.

You see, every little change makes a letter look different. By now you should appreciate the principles of how lettering works. Practice is the key.

H has 2 stems (vertical strokes) and a crossbar, which can be designed in so many possible ways.

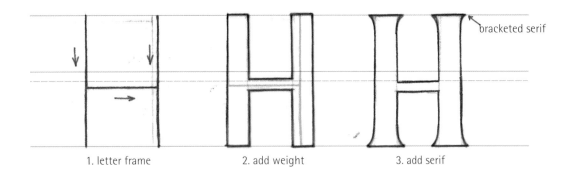

bracketed serif

1. letter frame 2. add weight 3. add serif

1. Draw your letter H following the direction arrows.

2. Add weight to your letter and adjust as necessary if you feel that you need more room to thicken the strokes. The two verticals should be thicker than the single horizontal line.

3. Begin by adding hairline serifs at the end of the two vertical stems. From that hairline, draw a small curve connecting the hairline serif and the stem, creating a bracketed serif.

Letter I is as straightforward as it gets—just a single vertical stroke .

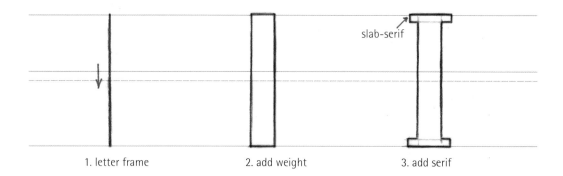

1. letter frame 2. add weight 3. add serif

1. Draw your letter I skeleton.

2. Add weight to the letter.

3. Add hairline serifs, duplicate these strokes and close them up like a rectangle to make a slab serif. You can exaggerate the serif by making it longer and, therefore, wider. But not by too much or it will look like a T!

If you think you can't draw a perfect curve stroke for J, here's a simple trick: Draw a circle to slightly extend below the baseline (this is an overshoot). Then, from the right edge of the circle, draw a vertical tangent to form your stem. From the stem, trace and follow the curve to form your **arc of stem**. Rub off the remainder of the circle.

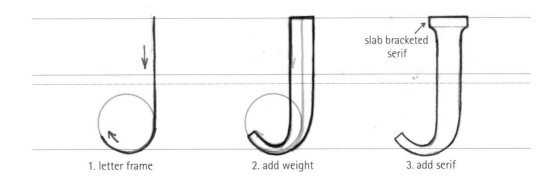

slab bracketed serif

1. letter frame 2. add weight 3. add serif

1. Draw your letter J following the direction arrows.

2. Add weight to your letter and adjust the thickness as needed.

3. At the end of the stem, along the cap height, draw a hairline. Repeat on the other side and close them up to form a rectangle. Then draw a curve stroke on both sides, attaching the hairline to the stem to create a slab-bracketed serif.

K is a very interesting letter. It comprises a **stem** (the vertical stroke), the **arm** (upward diagonal stroke), and the **leg** (downward diagonal stroke). Some key points about this letter: the arm is slightly extended below the mean line, while the leg is not attached to the stem but to the arm, and is slightly extended further to the right.

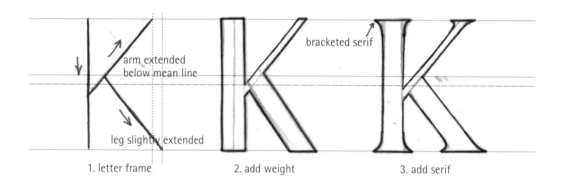

1. letter frame 2. add weight 3. add serif

1. Draw your letter K following the direction arrows.

2. Add weight to the letter. Pay attention to the details, especially where the strokes meet.

3. Begin by adding a hairline serif at the end of each stroke. Work it up into a bracketed serif by adding a curve bracket from the hairline near the stem.

Letter L has a stem and a bar. It is one of the easiest letters to draw and is a character you can play with because its strokes give you the flexibility to manipulate them by adding flourishes and exaggerated serifs.

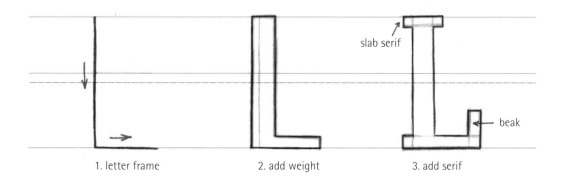

1. letter frame 2. add weight 3. add serif

1. Draw your letter L following the direction arrows.

2. Add weight to the vertical stroke.

3. Add a hairline serif, repeat the strokes and close them up to form a rectangular slab serif. Add a short vertical line at the end of the leg, this is called the **beak**.

The M can be tricky and easy to get wrong. But you can work with the strokes in different ways depending on where you place the midpoint or **vertex**. It can sit along the baseline, or alternatively you can extend the midpoint below the mean line. Play with the shapes to try out different effects.

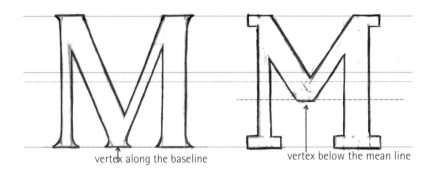

vertex along the baseline vertex below the mean line

The M is a wide letter, making it particularly eye-catching. So learning the correct strokes of the letter is important for your hand-lettering, because it contributes to the legibility and elegance of your lettering and, in turn, to your overall composition.

No two weighted strokes of this letter are parallel and this can cause novice letterers to get confused about where they should add thickness, especially in relation to the surrounding letters.

Study the strokes for drawing the letter M skeleton (as illustrated above right) before you start, as this will help you identify where to properly add weight.

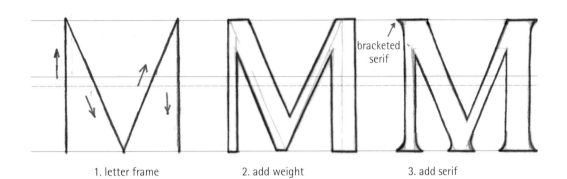

1. letter frame 2. add weight 3. add serif

1. Draw your letter M following the direction arrows.

2. Add weight, carefully paying attention to the strokes as illustrated. Then make adjustments as necessary.

3. Begin with your usual hairline serif and add bilateral serifs at the end of the bottom strokes. As for the top stroke, you can choose to add a unilateral or bilateral serif depending on your style and overall balance.

N is drawn in a similar manner to the letter M—and beware, the strokes of this letter are equally confusing! Letterers often make the mistake of adding thickness to the two vertical strokes instead of to the single diagonal stroke.

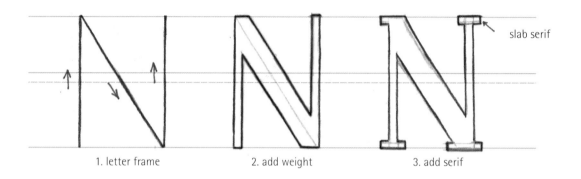

slab serif

1. letter frame 2. add weight 3. add serif

1. Begin by drawing a stroke from the baseline to the cap height, a diagonal stroke downwards and an upstroke.

2. Add weight to your letter. With all the strokes in place, you now know that the middle diagonal of N has easily the thickest stroke.

3. Add your hairline serifs, repeat, close them to form rectangles and make a slab serifs. You can choose to add bilateral or unilateral serifs at the end of the diagonal stroke.

When I was learning to draw letters, I always drew rectangles as guides to show how wide my letters should be. It became my routine, specifically for drawing curve letters like C, G, O, and Q. The illustration below, is a simple rectangular guide. Because O is round, it will have an **overshoot** not just above the cap height and below the mean line, but on both sides of the rectangular guide as well.

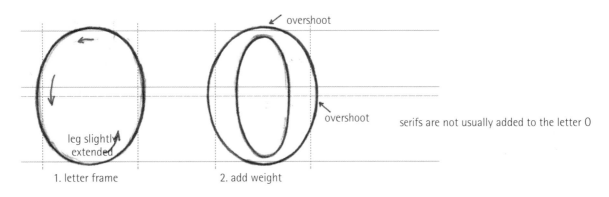

overshoot

overshoot

serifs are not usually added to the letter O

leg slightly extended

1. letter frame

2. add weight

1. Draw your letter O skeleton with a rectangle in mind.

2. Add weight to the letter. Remember to gradually taper the thickness where it is needed—wide at the mid-section and thinner towards the top and base—usually from a thin stroke going to a thick stroke.

3. The letter O doesn't typically have a serif. However, in some cases where you draw an ornate letter O, you can add a serif-like accent to it. We will explore more about this later.

P has a stem and a **lobe** that is extended below the mean line. Just like the letter F, the lobe of this letter leaves negative space at the bottom and extending it further below the mean line minimizes that negative space and creates balance.

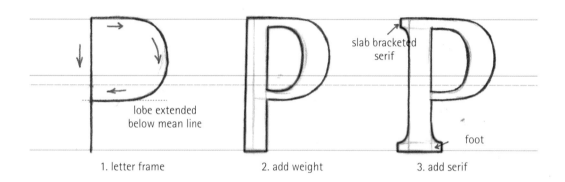

slab bracketed serif

lobe extended below mean line

foot

1. letter frame 2. add weight 3. add serif

1. Draw your letter P following the direction arrows.

2. Add weight to your letter.

3. Add a hairline serif, duplicate the strokes and close them up to form a rectangle, so creating a slab serif.

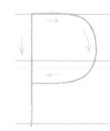

Q is similar to letter O in terms of drawing, plus it has an interesting descending stroke called a **tail** that designers love to play with. Q is round and therefore overshoots above the cap and below the baseline in order to appear the same size as other letters.

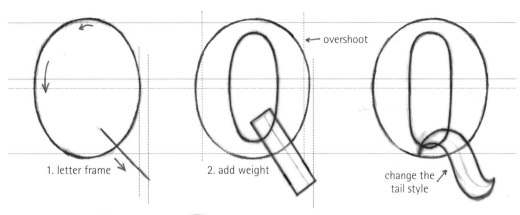

1. letter frame
2. add weight
← overshoot
change the
tail style

1. Draw your letter Q following the direction arrows. Take note that the tail is slightly extended diagonally down and out to the right.

2. Add weight to your letter following the strokes and the required thickness.

3. The Q's tail enables a designer to play with it and therefore find a way to convey a specific serif style. You can opt to keep the straight descending stroke or move it around to give character.

Letter R has a **stem**, a **bowl**, and a **leg** that is typically extended
further to the right. It is designed so that the bottom part appears
heavier ensuring the letter doesn't look as if it's about to topple over.

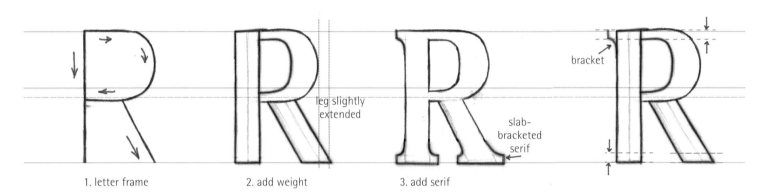

1. letter frame 2. add weight 3. add serif

1. Draw your letter R following the direction arrows.

2. Add weight to the letter and remember to taper the thickness when you're working on a curve stroke. (By this stage, you should've remembered this already!)

3. Draw the usual hairline at the end of the strokes. Repeat it and follow the thickness of the horizontal stroke (since your serif in this letter is horizontal). Add a curve bracket to finally create a slab-bracketed serif.

Letter S is another curve stroke and its main curve is called a **spine**. Its upper part is typically smaller than the bottom part. Achieving those perfect curves can be tricky at first but once you get used to it, it's easy.

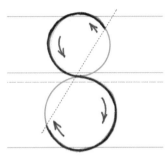

1. letter frame

1. Draw your letter S following the direction arrows—if you find this tricky use a guide to help out. In this case, you can draw two circles and form an 8 (the upper circle being a tad smaller than the bottom one). Then, draw a diagonal line which will serve as your **opening** and **terminal points**.

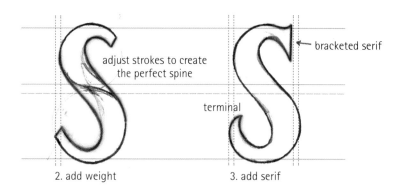

adjust strokes to create the perfect spine

bracketed serif

terminal

2. add weight

3. add serif

2. Slowly, add weight to the letter paying attention to the curves and where you taper the thickness. Concentrate on perfecting your spine. Look at the two circles: The inner part of the upper circle connects to the outer part of the bottom circle, while the outer part of the top circle connects to the inner part of the bottom circle.

3. Just as with C and G, draw a hairline at the opening stroke of S. Work on your serif by adjusting the curve strokes as you see fit. By now you have learned quite a lot and it's time to add a terminal to your letter—you can either use a **ball**, a **teardrop**, or even a **pointed terminal**!

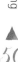

When drawing the skeleton of your T, you need to define the size or width of your letter by drawing the **bar** (top) first, followed by the vertical stem.

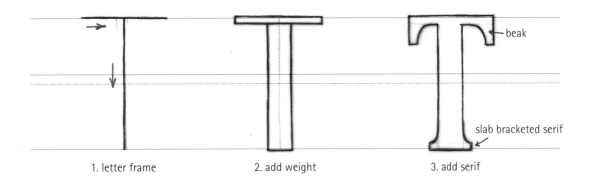

1. letter frame 2. add weight 3. add serif

beak

slab bracketed serif

1. Draw your letter T following the direction arrows.

2. Add weight to the letter.

3. Then add the hairline at the end of each stroke—vertical strokes for the bar and horizontal for the stem. At this point, I want you to go back to the letter L and refer to how we added the slab serif and the beak to the bar. Do the same thing to the letter T and then add a **curve bracket** connecting the bar and the beak. creating a slab bracketed serif.

Remember the technique we used for drawing the letter J? We'll do it again with U.

slab serif

1. letter frame 2. add weight 3. add serif

1. Draw a circle along the baseline paying attention to the overshoot. Now, draw parallel vertical lines at the left and right edges of the circle. This will be your stem.

2. Add weight to the letter by going inside and thickening the stroke. If you have not drawn your skeleton wide enough to accommodate the weight, you can always adjust it or simply start again.

3. Finally, add a hairline serif, repeat at the ends and close them up to form a slab serif.

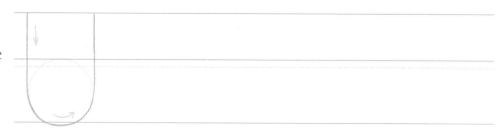

Letter V is similar to an inverted letter A minus the crossbar. You may render it with a flat vertex or a pointed vertex—whichever you want. Do take particular note of the overshoot, though, when you draw it with a pointed vertex.

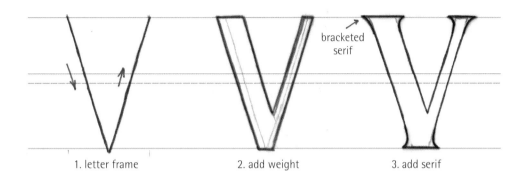

1. letter frame 2. add weight 3. add serif

1. Draw your letter V following the direction arrows.

2. Add weight to the letter, thicker on the left than on the right.

3. Add the usual hairline at the end of each stroke as well as at the base. Then, draw a curve bracket and complete your bracketed serif.

W is the widest letter in the alphabet—just slightly bigger than the letter M, (but not as wide as putting two Vs together). Just like the letter M, it can be rendered in different ways depending on where you choose to put your **apex**—either where the apex is resting at the cap height or when the apex is extended above the mean line.

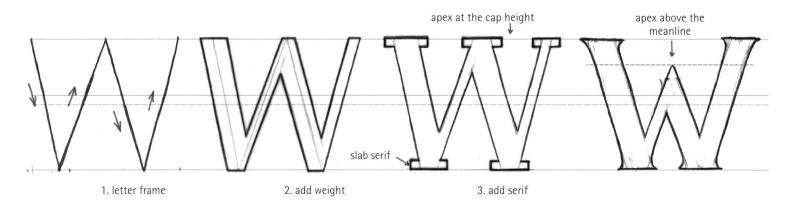

apex at the cap height

apex above the meanline

slab serif

1. letter frame

2. add weight

3. add serif

1. Now, draw your skeleton depending on how you want to present the apex of your W.

2. Add weight to the letter following the strokes as illustrated above. Note that the left leaning verticals are thicker than the right leaning verticals.

3. Finally, add a hairline at the end of each stroke, at the apex and **vertices** (base). Repeat the stroke and create a slab serif.

The letter X has two intersecting diagonal strokes with the lower part being larger than the upper part (like the S).

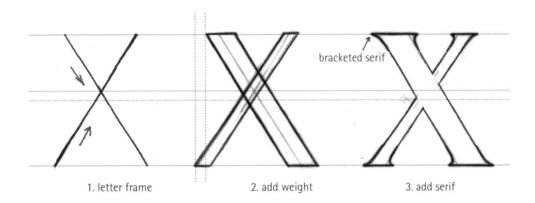

1. letter frame 2. add weight 3. add serif

bracketed serif

1. Draw your letter X following the direction arrows.

2. Add weight to the letter. Adjust your diagonal strokes as needed depending on the thickness you want to give.

3. Finally, create a bracketed serif by drawing a hairline and adding a curve bracket to it.

Letter Y has two diagonal strokes meeting at a point slightly below the mean line called the **crotch**.

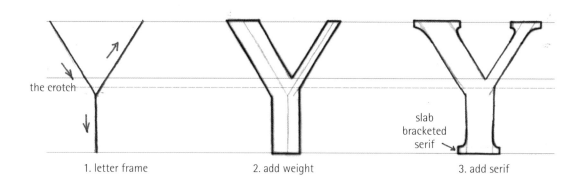

the crotch

1. letter frame

2. add weight

slab bracketed serif

3. add serif

1. Draw your letter Y following the direction arrows. Two symmetrical diagonal strokes plus a vertical stroke meeting at a point called the **crotch**.

2. Add weight to the letter adjusting as necessary.

3. Add your slab-bracketed serif by drawing the hairline, repeating the stroke then adding a curved bracket to the serif.

Like S and X, the top part of the letter Z is also narrower than the bottom part. Define the width of your letter first and use it as a guide for when you need to add weight.

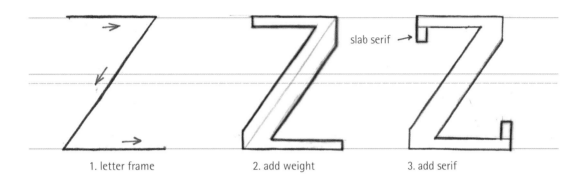

slab serif →

1. letter frame 2. add weight 3. add serif

1. Draw your letter Z following the direction arrows.

2. Add weight to the letter maintaining the outermost line guides. Adding vertical strokes to your diagonal will help you keep the size of your letter in proportion.

3. Finally, our last letter will be a slab serif. So add a vertical hairline serif and repeat it to form your slab.

Lowercase Letters

Now that we've learned the techniques for uppercase letters, we're moving on to the lowercase alphabet. And these are just as fun to explore! Also I find them much easier, because uppercase letters have lots of sneaky quirks—far more than lowercase letters do.

As before, I am using contrasting letters so we can better study and understand the shaping of each stroke. By now this should be easy! Just bear in mind that for this particular exercise, we are drawing sans-serif characters then developing them into serif letters.

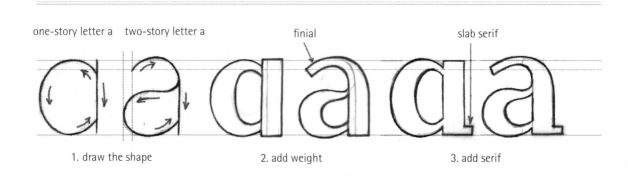

one-story letter a two-story letter a finial slab serif

1. draw the shape 2. add weight 3. add serif

1. The lowercase letter A can be rendered in two ways: as the one-story letter **ɑ** and the two-story letter **a**. Follow the strokes shown to draw your skeleton. Take note that you will have to curve the strokes, so remember that an **overshoot** is needed.

2. Once you've drawn the skeleton, add weight. And similar to uppercase curve letters, you will have to taper your curves with the lowercase letters too. Pay attention to your upstroke and downstroke.

3. Now, you're ready to add a serif to your lowercase a. Remember how we did the uppercase letters? We'll do the same thing here. Begin with a hairline serif at the base of your stem and then work it up to your desired style. In this case, a slab serif.

You might be wondering, why not add a serif on the left side of the stem too? See that very little space between the bowl and the stem? Yes, it's too narrow and adding another stroke in there is not aesthetically pleasing. In the same manner, you don't need to add another stroke on the upper part of the stem on that one-story a either. The weight of the letter should typically be greater at the bottom for visual balance and aesthetic appeal.

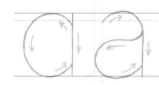

Lowercase letter b has a stem and a bowl. This is the first letter we have covered with an **ascender**.

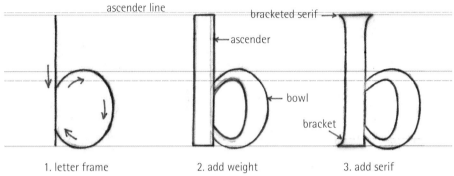

ascender line
bracketed serif →
←ascender
← bowl
bracket

1. letter frame 2. add weight 3. add serif

1. Draw your letter b following the direction arrows.

2. Slowly add weight to the strokes by following the arrows and keeping the downstroke thick. Taper your curves whenever necessary.

3. Once you've created your sans-serif b, you can add the hairline stroke and begin working on your serif letter. Similar to a, the lower part of the stem will have a unilateral serif. The upper part, however, this time has enough space to add a bilateral serif.

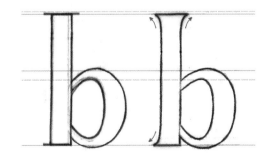

c is basically similar to its uppercase partner.

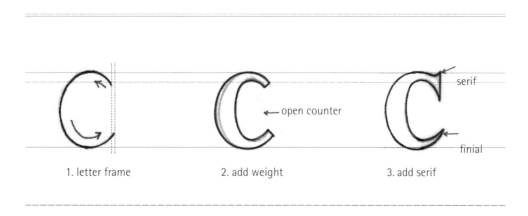

1. letter frame 2. add weight 3. add serif

1. Draw your lowercase letter c following the direction arrows.

2. Add weight and taper the curves as necessary.

3. Still remember how we added a serif to an uppercase C? Yes, the hairline stroke. Draw a small vertical stroke at the top of the letter. Once you have this stroke, you can immediately draw a curve and attach both strokes together and create your bracketed serif. Easy peasy.

Similar to b, lowercase d has a bowl and a stem and comprises basically the same strokes—just the other way around.

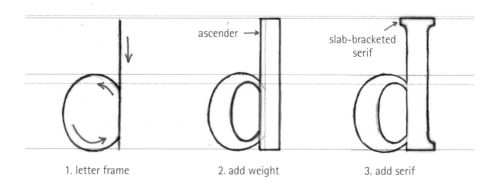

ascender →

slab-bracketed serif

1. letter frame 2. add weight 3. add serif

1. Draw your letter d following the direction arrows..

2. Add weight to your strokes.

3. Create the same block-like serif at the top and bottom of the stem. From that slab-serif, draw your bracket (curve stroke) connecting the serif and the stem as shown above.

The lowercase e has a unique element—the **eye**. This specifically refers to the enclosed part of the letter.

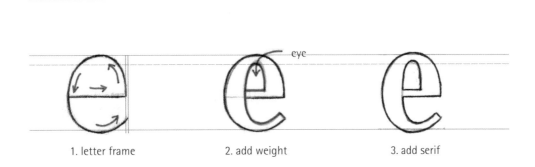

1. letter frame 2. add weight 3. add serif

1. Draw your letter e following the direction arrows.

2. Add weight to the letter, but keep the horizontal x-stroke thin.

3. The lowercase e typically doesn't have a serif.

Lowercase f has a part called the hook (or arch). It is usually a curve stroke connecting a terminal.

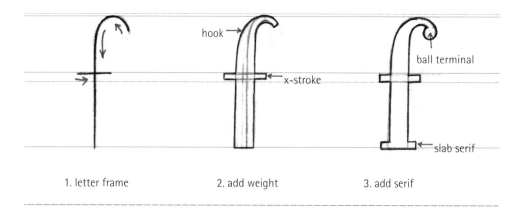

1. letter frame 2. add weight 3. add serif

1. Draw your letter f following the direction arrows.

2. Add weight to the letter, but keep the x-stroke thin.

3. This time adding a serif down at the base is easy. As usual, begin with the hairline stroke and style accordingly. Along the **hook**, you can add either a ball or a teardrop terminal. But leave the x-stroke as it is.

You can render the lowercase g in several ways. Similar to a, it has two common variations, the one-story **g**, and the two-story **g**. The latter though, depending on how you render the link and the loop, can create a couple more variations.

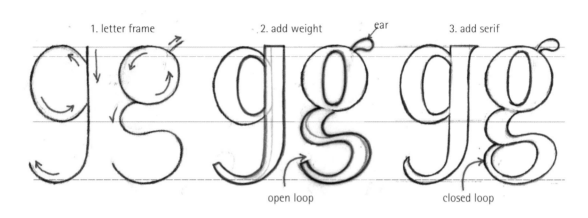

1. letter frame 2. add weight ear 3. add serif

open loop closed loop

1. Draw your letter g following your preferred version direction arrows.

2. Add weight following the strokes.

3. Add a bracketed serif to the top of the one-story g. As for the terminal at the bottom, you can choose to match the design of your bracketed serif or have a ball or teardrop terminal instead.

Lowercase h has a stem and a shoulder, which is a curve stroke aiming downward from the stem.

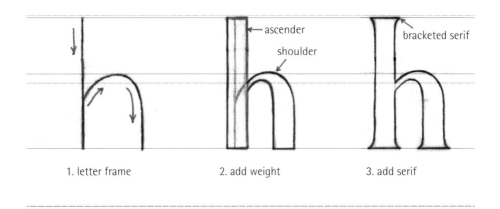

1. letter frame 2. add weight 3. add serif

1. Draw your letter h following the direction arrows.

2. Add weight to your letter, tapering curves wherever necessary, but keeping the junction between the ascender and **shoulder** elegantly slim.

3. Again, begin by adding a hairline serif at the endpoints of every stroke. From that hairline, draw a small curve connecting the serif and the stem, creating a bracketed serif.

Similar to its uppercase cousin, lowercase i is basically the same. It has a single vertical stroke from the x-height to the baseline, plus a tittle (or dot).

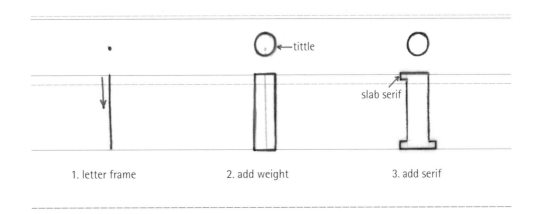

1. letter frame

2. add weight

3. add serif

1. Draw your lowercase i following the direction arrow.

2. Add weight to the letter and add the **tittle** or dot above the stem.

3. Add a hairline serif, repeat on the other side and close them up like a rectangle, creating a slab serif. Make sure the base of the letter i appears heavier so it looks safely balanced, therefore, add a unilateral serif at the top and bilateral serifs at the bottom.

Lowercase j is drawn similarly to the uppercase J except that its arc of stem is shorter and not as elaborate as the uppercase. It also has a tittle like the letter i.

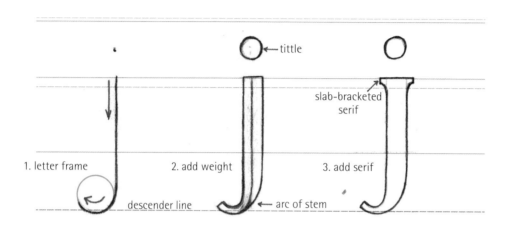

1. letter frame 2. add weight 3. add serif

tittle

slab-bracketed serif

descender line arc of stem

1. Draw the skeleton of the lowercase j in a similar fashion to its uppercase cousin, but start at the x-height and extend the stem to the descender line connecting to the arc of stem. Add a tittle similar to the i.

2. Add weight to your letter and adjust the thickness (or weight) as necessary.

3. Now, draw a hairline at the top, repeat on the other side, and close them up to form a rectangle. Then draw a curve stroke attaching them to the stem, creating a slab bracketed serif.

Lowercase k is basically drawn in the same way as an uppercase K, except somewhat shorter—its arm is drawn upward extending only slightly above the x-height. Its leg is still connected to the arm and extended slightly to the right to achieve visual balance.

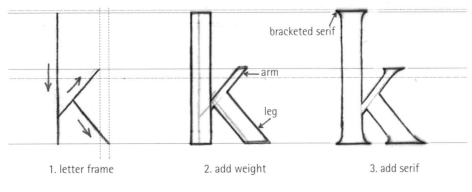

bracketed serif

arm

leg

1. letter frame 2. add weight 3. add serif

1. Draw your letter k following the direction arrows.

2. Add weight to the letter, paying particular attention to the placement of the strokes.

3. Begin by adding a hairline serif at the end of each stroke. Work it up to make a bracketed serif by adding a curve bracket from the hairline towards the stem, then the arm, and the leg.

Lowercase l looks a lot like an uppercase i, just a bit smaller!

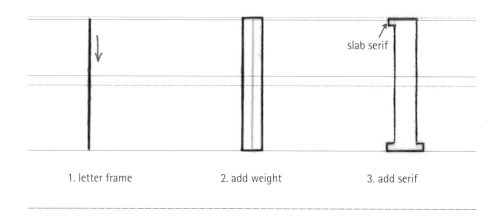

1. letter frame 2. add weight 3. add serif

1. Draw your l following the direction arrow.

2. Add weight to your letter.

3. Add a hairline serif, on the left of the ascender (but not on the right as it could then look dangerously like an l). Repeat the strokes and close them up to form a rectangular slab serif. As with the lowercase i, add two serifs at the bottom to give visual balance.

Lowercase m, has a stem and two curve strokes called shoulders.

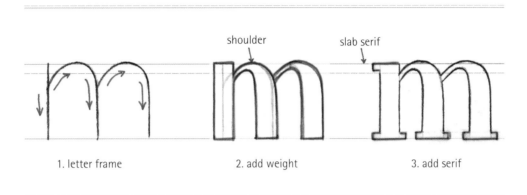

shoulder slab serif

1. letter frame 2. add weight 3. add serif

1. Draw your letter m following the direction arrows.

2. Add weight. Taper the curves as necessary but keeping the junction of the shoulders slim.

3. Begin with your usual hairline serif and work it up to form a slab serif. Because of the restricted space at the top, the top of the stem will have a unilateral serif and bottom ends will have bilateral serifs.

The lowercase n is drawn as half of the letter m. However, the aperture of the letter n is wider than that of the letter m.

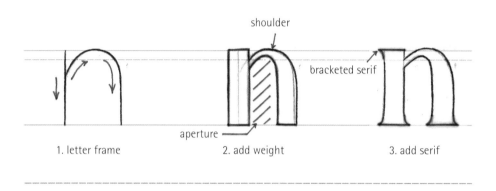

1. letter frame 2. add weight 3. add serif

1. Draw your letter n following the direction arrows and make sure to leave a substantial **aperture**.

2. Add weight to your letter but still keeping the wider gap (than with the M) between the verticals.

3. Add your hairline serifs and finish them up as bracketed serifs.

Lowercase o is basically the same as its uppercase, and therefore, drawing them will be very much the same—but don't forget the overshoot!

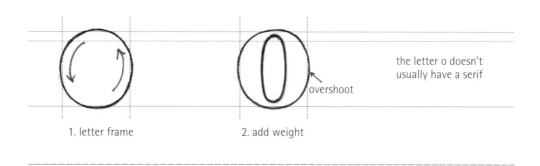

1. letter frame

2. add weight

overshoot

the letter o doesn't usually have a serif

1. Draw your lowercase o the same way you did with the uppercase O by placing it within a square frame (this can be rubbed off later).

2. Add weight to the letter. Remember to gradually taper the thickness proportionally where it is needed at the top and bottom.

3. The letter o doesn't typically have a serif. However, in some cases where you draw an ornate letter o, you can add a serif-like accent to it. We will explore more on that in the next chapters of this book.

The lowercase p is almost like its uppercase cousin except that the lobe is smaller and sits within the area between the x-height and the baseline.

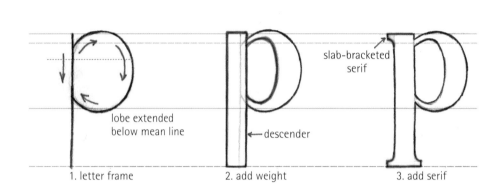

1. letter frame 2. add weight 3. add serif

lobe extended below mean line

descender

slab-bracketed serif

1. Draw your letter p following the direction arrows.

2. Add weight to your letter. Taper the thickness of your curves where necessary.

3. Finally, add a hairline serif and work it up to form a slab bracketed serif.

Lowercase q looks like a reverse p, but it is drawn with the bowl first, followed by the stem, and then the descender.

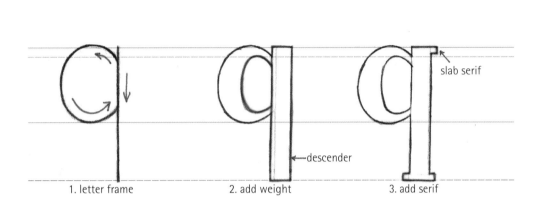

1. letter frame 2. add weight slab serif descender 3. add serif

1. Draw your letter q following the direction arrows.

2. Add weight to your letter following the strokes and the required thicknesses.

3. Add a slab serif to the letter. I am pretty sure that, by now, you know how to do this.

Lowercase r has a stem and a terminal. You can vary the terminal depending on the style of your letters. The commonest terminals are teardrop and ball terminals which can be used stylistically with almost any letter style.

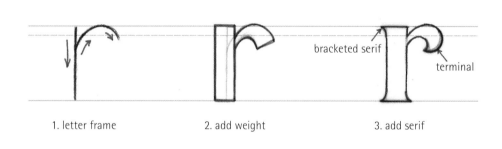

1. letter frame 2. add weight 3. add serif

bracketed serif

terminal

1. Draw your letter r following the direction arrows.

2. Add weight to the letter. Remember to taper the thickness on the curve stroke slimming it down where it meets the stem.

3. Draw the usual hairline at the end of the strokes and work up your serif. Finish the letter up with a ball or teardrop terminal or a serif—whichever matches your style.

In the previous section you learned the trick of perfecting the spine of the uppercase letter S. Its lowercase version is drawn exactly the same way, so use the same technique here.

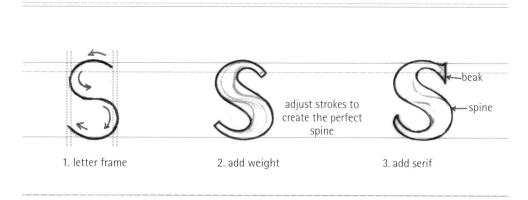

1. letter frame 2. add weight 3. add serif

adjust strokes to create the perfect spine

beak

spine

1. Draw your s following the direction arrows.

2. Slowly, add weight to the letter paying attention to the curves and where to taper it. Perfect the spine by taking your time and adjusting as needed to get it right.

3. Just as we did with c, draw a hairline at the opening stroke of s. Work on the serif by altering the curve strokes as you see fit. Then finish it with an interesting terminal!

Lowercase t has a stem and a cross-stroke, and sometimes a terminal. Draw your skeleton as shown. You can draw a curve stroke towards the baseline if you want to create a **terminal curve**.

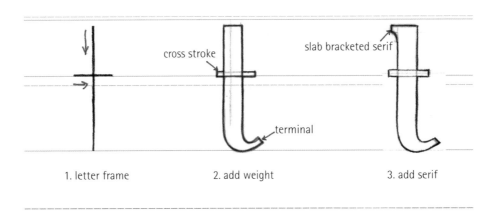

cross stroke

slab bracketed serif

terminal

1. letter frame

2. add weight

3. add serif

1. Draw your letter t following the direction arrows. Place the cross stroke two-thirds of the way up the vertical stroke.

2. Add weight to your letter but leave the cross stroke light.

3. For this letter, just a unilateral serif at the top will suffice.

Lowercase u is basically an inverted n. Take note of the curve
strokes and where you should taper them.

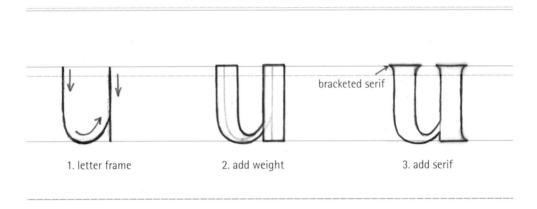

1. letter frame 2. add weight 3. add serif

bracketed serif

1. Draw your letter u following the
direction arrows.

2. Add weight to the letter. If you have
not drawn your skeleton wide enough
to accommodate the weight, you can
always adjust or redraw.

3. Finally, add your bracketed serif.

The lowercase v is the same as its uppercase, just smaller. You also draw the skeleton the same way.

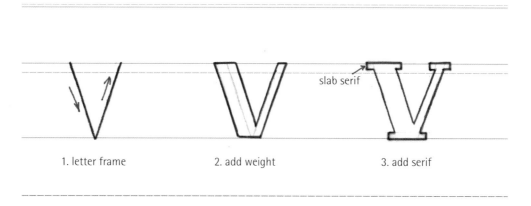

1. letter frame 2. add weight 3. add serif

1. Draw your letter v following the direction arrows.

2. Add weight to the letter on the left side only.

3. Add the usual hairline at the end of each strokes as well as the vertex. Then, form a slab serif to finish it.

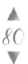

While lowercase w is similar to its uppercase, it can only be rendered with its apex along the x-height.

1. letter frame

2. add weight

vertex

bracketed serif

3. add serif

1. Draw your letter w following the direction arrows. Basically, it's the same as its uppercase and the biggest letter of the lowercase alphabet.

2. Add weight to the letter following the strokes as illustrated above.

3. Finally, add a hairline at the end of each stroke, apex, and vertices. Finish it with bracketed serifs.

Lowercase x, like most of the other letters, is drawn the same way as its uppercase counterpart.

1. letter frame 2. add weight slab serif 3. add serif

1. Draw your letter x following the direction arrows. Just like the uppercase, the lower part of the letter is slightly wider than the upper part.

2. Add weight to the letter along the left descender. Adjust your diagonal strokes as needed depending on the thickness you are after.

3. Finally, create a slab serif to finish.

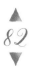

The two diagonal strokes of the y meet at the crotch and then extend to the descender with a tail. The crotch is generally drawn slightly below the baseline.

1. letter frame 2. add weight 3. add serif

1. Draw your letter y following the direction arrows.

2. Add weight to the letter. For the lowercase y, the thickness is usually on the left diagonal stroke while the tail has a thinner stroke.

3. Add your slab serifs at the top of the strokes. Finish the letter by adding a ball terminal to the tail.

The top part of the lowercase z is narrower and also shorter than the base. Define the width of your letter first and use it as a guide for where you need to add weight.

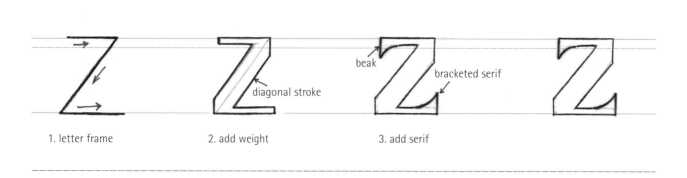

1. letter frame 2. add weight 3. add serif

1. Draw your letter z following the direction arrows.

2. Add weight to the letter with your thick stroke being the diagonal stroke.

3. And to complete our lowercase, finish the z with a bracketed serif.

Now practice the alphabet . . .

Uppercase Script

In the previous section you've learned to draw sans-serif and basic serif letters. Now, you will be drawing Script lettering based on what you have learned so far. Script writing is like imitating the strokes made by using a brush, nib pen, and other tools to write elegant letters. It is based on writing fluid strokes and is similar to cursive and calligraphy lettering.

The following pages give you the complete uppercase and lowercase script alphabet, along with guidelines and directional arrows for you to use to write your own script lettering. Use your knowledge of the upstrokes, downstrokes, and thicknesses to embellish your letters.

1. Follow the directional arrows to draw your letter skeletons.
2. Trace the provided script to add thickness—as shown by the purple shadow—so you can see how to add weight to a script letter.
3. Draw your own script alphabet and/or form your own words on the provided practice pages.

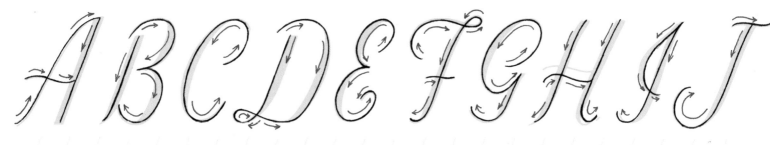

K L M N O P Q R S

T U V W X Y Z

Lowercase Script

Use the lowercase script alphabet to practice lettering. Again, use the skeleton for shape and form, then follow the green shadows to fill out the weight. Use the practice pages and then try combining the upper and lowercase scripts together.

1. Follow the directional arrows to draw your letter skeletons.

2. Trace the provided script using the green shadows to show the added thickness. This will show you how to add weight to each script letter.

3. Draw your own script alphabet and/or form your own words on the provided practice pages.

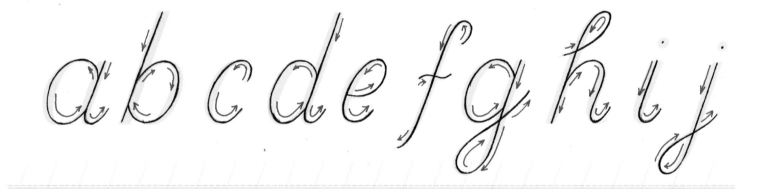

k l m n o p g r

s t u v w x y z

Isn't that great? We're done with the alphabet! Now, the next thing to do is to practice. Make use of the practice section of this book. You can only get better and better with the more you do. The best way is to develop a daily lettering habit—then you will definitely improve a lot!

WE ARE Travelers IN THE WILDERNESS OF THIS WORLD

COMPOSITION & HIERARCHY

A good composition rarely happens by chance. Instead it develops during the process of creation through experimentation and exploration of all the possibilities. The start of this process is learning and understanding what makes a good layout.

1. HIERARCHY

Establishing the hierarchy is the most important step in creating a strong, compelling structure for your layout. To put it simply, hierarchy is arranging the words in your composition giving EMPHASIS to the MOST IMPORTANT words and reducing attention on the less significant words.

You might find these steps useful in establishing hierarchy.

- Identify the linking words such as—is, at, and, of, to, etc. These linking words are usually less important (tho still necessary) and are drawn smallest.
- Identify the keywords that need to be highlighted. These are the first thing that you want people to see and are words that "speak" even without the linking words, and still deliver the message. They are typically drawn bigger, bolder and with more details to attract attention.
- Identify the less significant words. These words supply extra detail but are not linking words. They are drawn with less detail, thinner, and much smaller than the keywords, but still larger than the linking words.

2. LAYOUT STRUCTURE

Building the layout structure is the next step. This can seem complicated, but there is an easy way. When I was starting out, I put all my letters into a (notional) rectangle. That way I could measure my letters into a controled space where I could manipulate and design them. When I'm happy with it, I use that container shape to form words and then, phrases. I still use this method today.

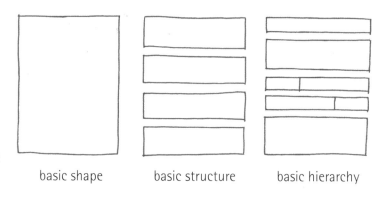

basic shape basic structure basic hierarchy

After establishing hierarchy, the next step is to create your layout structure.

- Begin with the simplest shape.
- From that shape, create your basic structure.
- Using your hierarchy as a guide, identify spaces where you can place the important words, then the less significant words, and finally the linking words. This is your basic hierarchy structure.
- Use this structure when you work on your lettering.

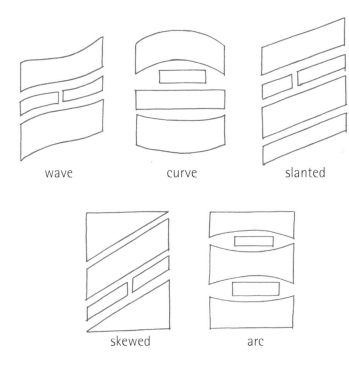

wave curve slanted

skewed arc

There are lots of exciting ways to create your structure. Working from the basic shape, you can form shapes like waves, curves, diagonals, arcs, and more. Do not restrict yourself with what you see in front of you—always think outside the box—literally!

3. BALANCE

The correct distribution of weight and style is essential to achieve balance. The most important words are drawn bigger, bolder, and with more style, the less significant ones are drawn simpler and usually smaller, and linking words even smaller. Look at the example below.
The words WORK HARD, SHOP HARDER—will stand out even if you remove the less significant words. The message is still clear and understandable.

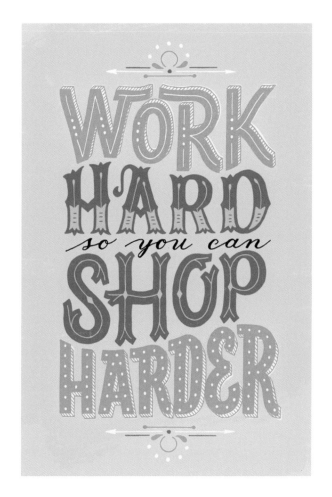

4. READABILITY

Who doesn't like seeing beautifully designed letters? We all do, right? But beautiful letters don't matter if the message is no longer clear because the words are hard to read and incomprehensible. It's all very well having a beautifully structured piece but if your letters are muddled your message won't be CLEAR.

The layout on the right is a piece I did a year ago. I was so distracted working things up with the negative space at the bottom while I played with the word ARE to fill the space, that I added a couple of flourishes that made the word look more like CARE. I didn't realize until I saw it the following day. Even worse, I'd already posted it on Instagram! It was a silly mistake but something I am willing to admit to. Mistakes are important—that's how we learn. So, learn not to be too hard on yourself too.

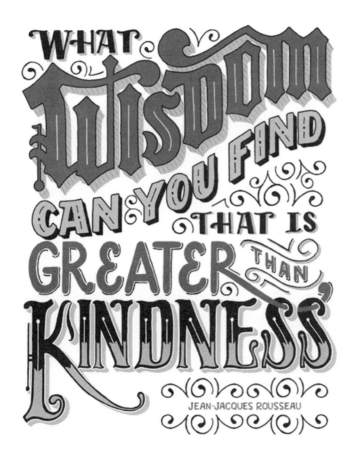

JEAN-JACQUES ROUSSEAU

5. NEGATIVE SPACE

In any given layout, more often than not, there will be negative spaces. And they can be annoying when the problem is not addressed properly. It is up to you to find an answer, but keep in mind the overall composition as well. There are various solutions: you can add elements like filigree, shapes, or exaggerated letters, add flourishes and more.

Look at the empty spaces in the layout on the left. With such a complex design, there is no room to adjust the words, so I added filigrees instead to fill the spaces up. I did the same thing below the word KINDNESS and used similar flourishes to create a border around the attribution.

There will be easy compositions and there will be trickier ones. As you move on to creating more complex layouts, experiment as much as you can—don't rush and settle for a mediocre layout. Create more versions of your initial artwork. Assess your own work, spot areas for improvement, and keep working until you are fully satisfied with the result.

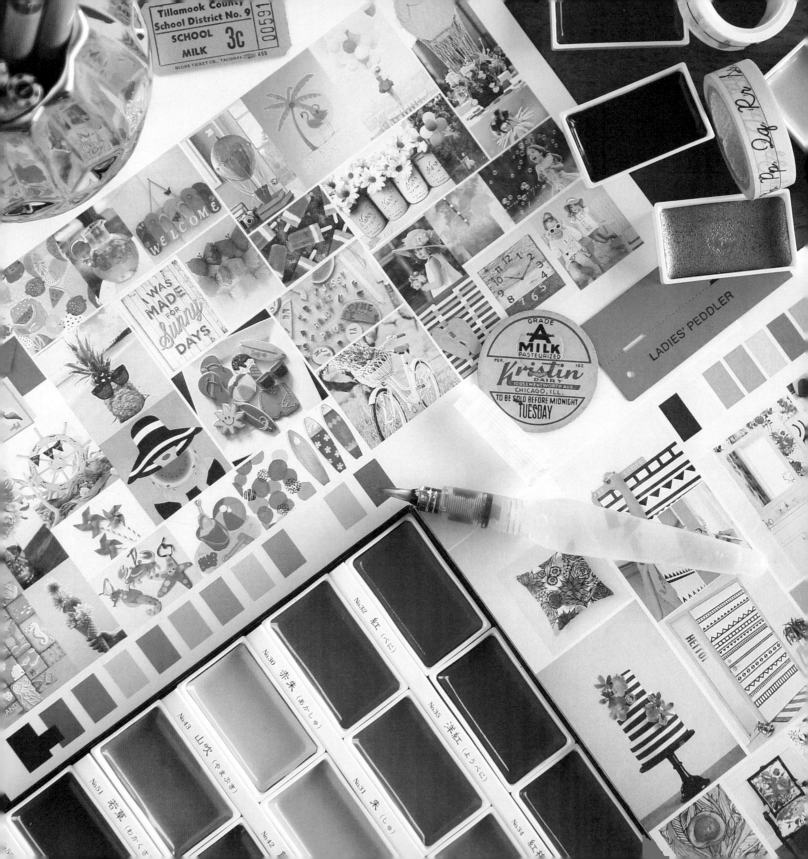

COLOR
~AND~
INSPIRATION

In this age of the Internet, almost everything is just a mouse click away—that includes various lettering work, both old and new, and lots of tutorials and articles about lettering. It offers easy access to learning as well as inspiration, and this is important for artists because that's how we produce new artwork. There is absolutely nothing wrong with looking for inspiration online, however, I would still encourage you to collect and curate your own ideas from the things all around you.

- Take pictures when you travel. Capture the mood, the scenery, the story. You'll spot things that will be unique to you and will surface through your interpretation when you use the ideas in your work.

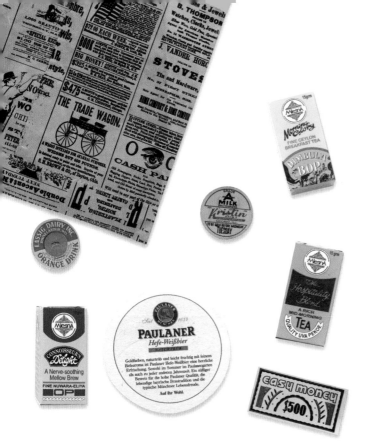

One of my color palettte selections.

CREATING COLOR PALETTES

Color is a crucial aspect when digitizing artwork. Personally, I do not have the technical know-how about the science of colors, but I do have a working level of understanding about when certain color combinations work and when they don't. And when I worked as a scrapbook designer, I was tasked with creating so many color palettes that colors have become a natural part of my process.

If you have Photoshop and Illustrator, you can simply pull up an image and use the color picker to select the colors. Sometimes, the combination may look good as it is, but they may not work in every layout. In that case, experiment. Change the combinations or remove a color that doesn't seem to fit. You don't have to select all the colors in the image, just choose those that you think would work best with your scheme.

- **Ephemera**. You know those insignificant things you see around you that other people think don't have any value? Coasters, tickets, tin cans, packaging, vintage postcards and so on. They are more valuable than you think: study the lettering, the colors, the presentation, the borders, the flourishes. Keep them.
- **Read books**. Not only will it help you unwind but when your brain is relaxed it works best creatively! Stories can help spark new ideas and who doesn't love a new idea?
- **Keep learning**. There is always something new to learn. It doesn't matter how small it is. Every little new thing is key to progress and will help cultivate your skills for the better.

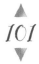

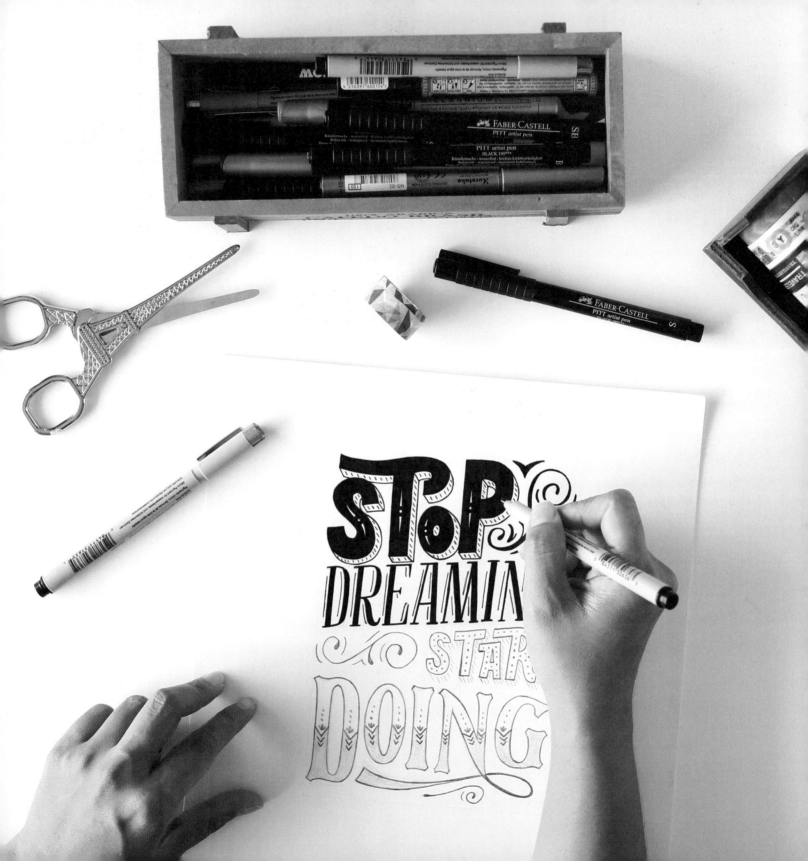

It's amazing to look at a meticulously produced layout done by a talented lettering artist. At first glance, you will only see the result—the beautiful composition, outstanding choice of color, a clear message, and overall, a compelling piece. But what really makes the artwork so wonderful? Is it the colors or the clever lettering? Most people will only look at the final artwork—and that's OK. But if you want to learn lettering, and even one day hope to make it a career, learning and understanding the process is very important.

A good lettering composition doesn't happen immediately. It takes time and a lot of experimentation on your piece before achieving your final layout. You need to be able to appreciate the process of creating and learn to be patient. Rushing into your composition will only yield a mediocre result that will be reflected in your capability and skills as a letterer.

In this section, I will be sharing my own creative process. Other artists may do things differently and that is definitely OK. Each of us has their own way of making art. You are free to learn from many artists: in fact, I encourage you to learn. Before you know it, you will have built your own process. For the purpose of this lesson, we will be creating a layout using the phrase: "Trust the Process" in which we apply the things we learned from our composition and hierarchy lessons.

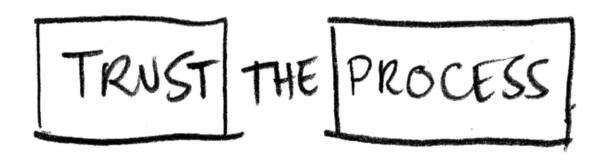

1. Sketching

- Write down the phrase on a piece of paper.
- Identify the keywords—these are the words that matter most in your composition, so basically the most important words.
- Sketch! Roughly work on potential layouts. Pay attention to the highlighted words. Remember, those words must be bolder, bigger, and need to grab the most attention.
- Work up some potential word designs and letter them—a script, a sans-serif, a serif. Push it into a shape. Try lettering on a path, or over a curve. Try everything. Work up as many designs as you can. Then choose the best and work more on them.

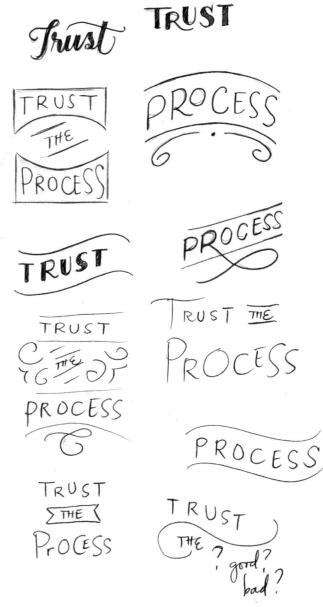

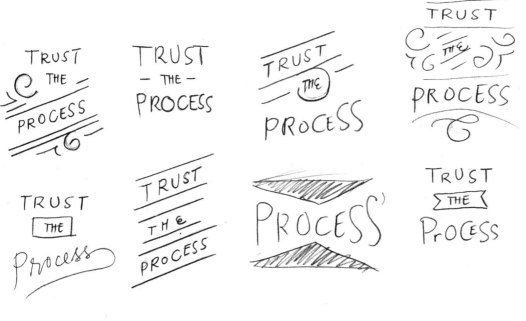

2. Thumbnail concepts

These are basically smaller layouts sketched to further enhance your workings. These allow you to explore, make changes, see the nuances, spot spaces, and any lurking problems before creating your proper layout. Sketch up a number of them.

- From these sketches select the best. This can be as few as three or as many as ten, but typically I settle for between four and six sketches that I think work best. You can also pick out word styles or other embellishments you think will work with your chosen layouts.
- Keep doing it until you are satisfied. Take your time in building your composition.

Work as loosely as you can, form different word styles, different shapes, explore all the different elements you can use to fill out your space.

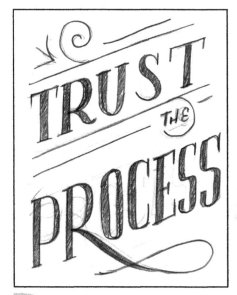

a

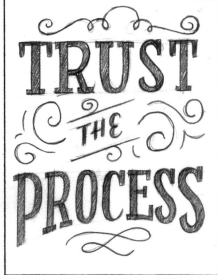

b

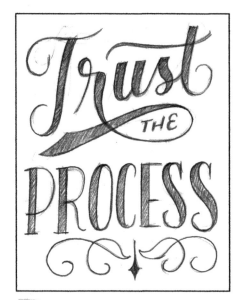

c

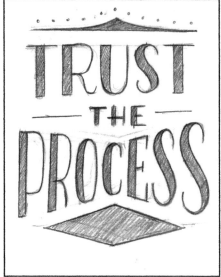

d

Try your own
versions here

3. Drawing your layout

The next step is to select the best layout—one that sends the message, is well presented, and shows well-balanced distribution of words and elements. Just choose one—if at first, that one doesn't work out, try another. Let the process teach you which one works best and which ones do not. I've chosen thumbnail "b" (from page 104) for this exercise because of the following:

Word placement. The word TRUST is shorter but I want it aligned with PROCESS: so I positioned PROCESS on an upright base curve so it doesn't occupy too much space and there is room to play more with TRUST.

Elements. There is plenty of room for these. I absolutely love playing around and embellishing my layouts.

Room for experimentation. There is plenty of space around TRUST. And where there's space, there's more scope to play and explore letter styles.

Now your turn: Redraw your layout sketch "e," (from page 105) but make it bigger. Experiment more. What else can you do? Try changing the elements: add or replace filigrees. When you're satisfied, create an overall first draft of your final layout.

Now work on your sketch "f," and start adding weight and style to your letters.

Pay attention to your letter spaces, and the negative spaces. Add or remove elements where necessary.

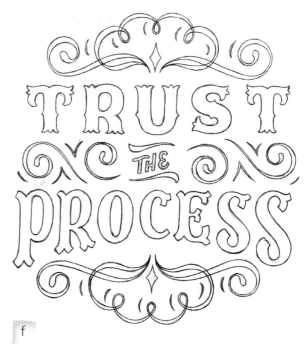

e

f

4. Refining your layout

Now I hope you believe your composition has taken shape and is looking better, but you're not done yet! The work doesn't stop after adding weight and style to your letters. When you have finalized your layout and everything appears in order, it's time to refine it.

- Look at your drawing once again. I like to do this with fresh eyes, so I'll stay away from the initial drawing for hours or, if I can, a day. This way, I will have an impartial eye when I look at it again. You can do that, too. It really works!

- Look for areas where you can make improvements. Can you make this word bigger? Do you need to adjust the tracking? Do you have to redraw the word to make your adjustments work? This is the stage where you do it.

- Add embellishments—like inline and drop shadows—and work in more details to your words, specifically to your keywords.

- In this layout, I saw an opportunity to add a dramatic vanishing point to the word PROCESS because of how it was styled. Also, look back at the drawing stage (on the left) and you'll notice the negative space between the word PROCESS and the filigree at the bottom. It needed filling out—and the central vanishing point proved the solution to that problem.

These little problems were not obvious during the initial stage of the design and the solutions would not have been possible if I hadn't taken the time to dwell on the different stages of the process. When I told you earlier that a good composition doesn't happen at once, this is a classic example.

If you have carefully followed these stages your layout will now have been carefully refined and finalized and ready for digitizing.

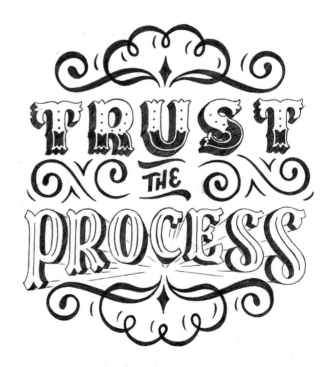

5. Inking

The first step before digitizing your layout is preparing it for scanning. Inking your artwork in black (using fine tip pens) will give you the best scan results—but your original layout must also be preserved. If something goes wrong, you can always go back to it. As much as possible **DO NOT** ink directly on your final layout. Not only will your scans be messier, but you will no longer have a pencil layout to go back to if you need it.

So the next step is to TRACE the layout. Use tracing paper and fine tip pens. If you are a beginner start with a 0.5 tip first. You only need to ink the outlines and inline details, the rest can be done digitally. You also need to make sure your tracing paper doesn't move while you are tracing. I prefer washi tape because it can easily be removed and replaced as I need it.

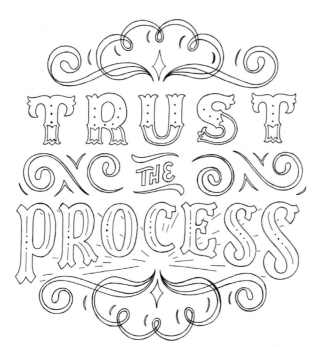

A few things to remember when tracing and inking:

1. Ink overlapping areas separately, if you can. For the filigree I had initially planned to use the same color as the lettering, so it's OK not to separate them. However, I might change my mind later, and until it is completely finished I can't be sure. So I traced it separately, this way I have all the elements in place and ready if I need them.

2. If you are comfortable with manipulating the shadows digitally, you don't need to trace them, but if you are not, then trace the shadows separately too.

3. Unless you are doing shadow lines, the shadow traces need to be closed shapes for your digital work. It doesn't matter if it is not perfect, just so long as you capture the necessary lines and areas.

6. Scanning

After inking your artwork, you need to scan it. Your scanner settings must be at least 300 dpi or higher for optimal quality. Since coloring will be done digitally, scan your images in black and white.

7. Digitizing

Digitizing your layout maximizes your artwork's potential use and selling factor. You can license the design, use it on products, sell it, and a lot more. It's also useful to learn how to digitize if you are working with clients who are thousands of miles away.

When digitizing, you can use software like Adobe Illustrator and Photoshop. I have used both, so I am happy to recommend them, though these days I mainly use Illustrator. If you are just starting, try using free software like GIMP or sign up for a free 14 day Photoshop or Illustrator trial with adobe.com.

- Open Adobe Photoshop and open your scanned image. Before using Illustrator, your artwork needs to be thoroughly clean and the contrast must be at its best. You can do this in Photoshop. Erase any dirt and specks that might have appeared. Adjust your levels to achieve better contrast.
- Transfer your files to Illustrator for Image Tracing. Adjust your Threshold and Paths depending on how smooth or rough you want your edges to be. I prefer the handmade feel of my original layout so I typically adjust the Threshold a little higher and my Path fittings higher than 90%.

- When you are happy with it, Expand and Ungroup then use the Shape Builder tool to fill in the letters and all your closed shapes (filigrees, dots, etc.)
- Do the same for your other layers (shadows, inline, drop lines, overlapping images, etc.)
- If you need to you can to you can assign temporary colors so you can identify which images belong where. For this layout, I used white for inline, black for main shapes like letters and filigrees, and gray for shadows so I can clearly see the entire composition.
- Group your vector images accordingly so they are ready for coloring.

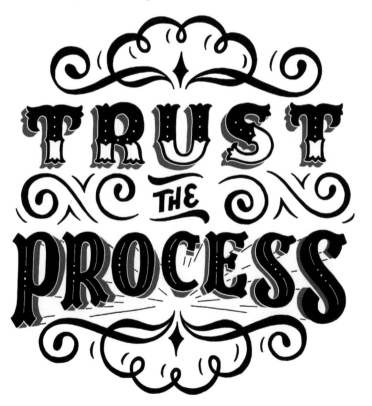

8. Coloring & texture

You are closing in on the final stages of your artwork. It's now time to add colors and it will be easier because you've already grouped your images accordingly.

Pull up your mood board or color inspiration and start picking colors for your letters, inline, and shadows as well as your background.

When you are happy with the layout, you can either add texture in Illustrator or Photoshop.

But whatever you do, remember to **SAVE** your files as often as possible. That way, if you have a program or computer crash, you won't have lost all your work!!

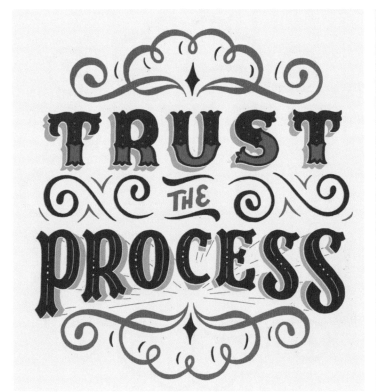

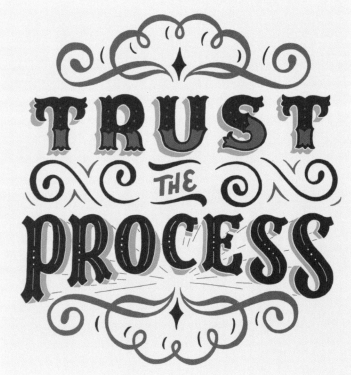

LEARN THE RULES LIKE A PRO SO YOU CAN BREAK THEM LIKE AN ARTIST

— PABLO PICASSO

LETTERING STYLES

Serif

How serif lettering started is a matter of debate, but it was most widely used in ancient times by Roman stone carvers who discovered that adding small extended decorative lines to the ends of their letters made their inscriptions easier to read. Johannes Gutenberg, the inventor of the moveable-type printing press, used serif fonts for legibility and generations of printers have followed. Many newspapers and magazines still print in serif lettering.

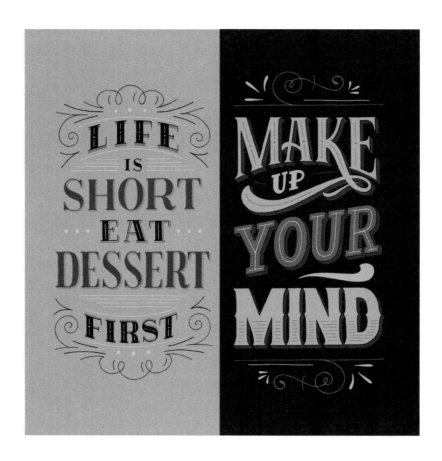

HAPPY BIRTHDAY

PIECE OF CAKE

SUGAR RUSH

1. For this layout, sketch out a guideline upper arc and lower arc to contain your words: use a compass or just draw the shape freehand. Sketch your letters. Then fill in the negative spaces with filigree or simple shapes such as a star or diamonds.

2. Add weight to your letters by going over the words again and filling them out. Start by adding simple serifs, you can always go back later and edit the serif styles to improve your layout.

3. Look over the composition again and check the letter spacing, spellings, and other details. Add inlines, drop shadows and any other elements you think would work well with your composition.

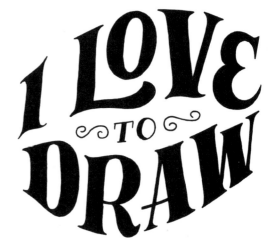

4. Finish your project by drawing it up in ink using tracing paper and a light box, or inking directly on top of the lettering. Alternatively, finish it in color, either digitally or using other mediums such as watercolor or poster paint.

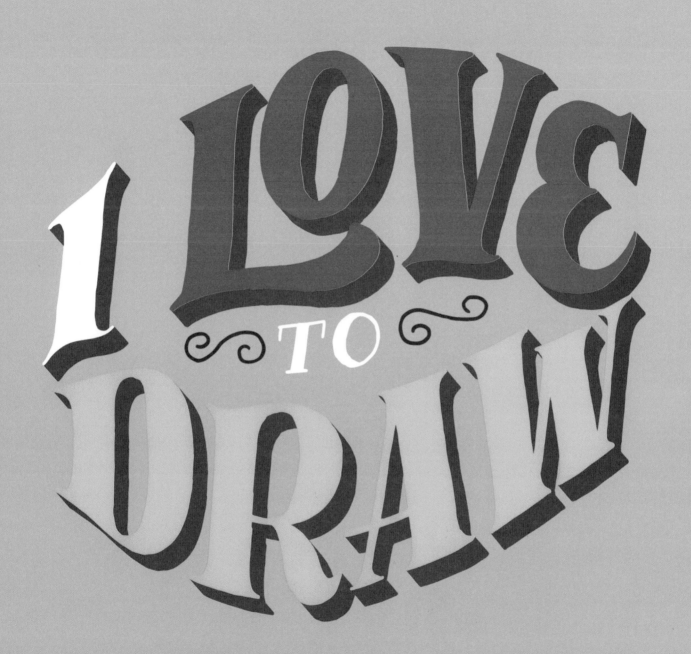

Sans-Serif

This cleaner style of lettering has immediate impact making it ideal for advertising purposes. Indeed, it first appeared in the 19th century on billboards and posters where it implied a more modern product and approach. But sans-serif lettering really only became ubiquitous with the arrival of computers where its clearer appearance is far easier to read on screen than serif fonts.

HUGS & KISSES

DINER

OLIVER & Co.
CAR PARTS
· ◆ · ◆ · ◆ · ◆ · ◆ · ◆ · ◆ ·
5TH AVENUE

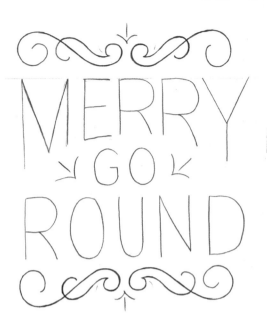

1. Draw a rough sketch of your piece. Try different word layouts such as slanted, arc, or wavy to change the look. Add your initial elements (here I have used scrolls) to produce an overall concept.

2. Start adding weight to your letters by going over the words again. Since sans-serif letters do NOT have any terminal projecting strokes, try different forms such as rounded letters; this way you can still have great variations of style.

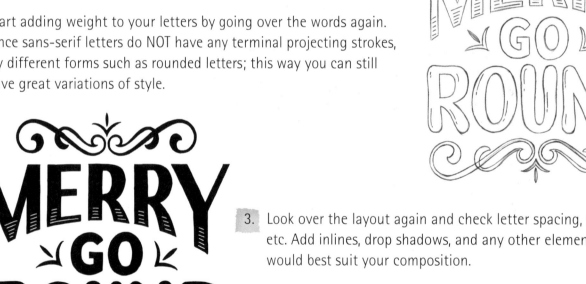

3. Look over the layout again and check letter spacing, spellings, etc. Add inlines, drop shadows, and any other elements you think would best suit your composition.

4. Finish your project by drawing it up in ink using tracing paper and a light box, or inking directly on top of the lettering. Alternatively, finish it in color, either digitally or using other mediums such as watercolor or poster paint.

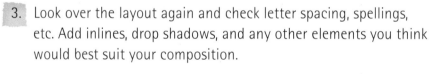

MERRY
GO
ROUND

Script

Script is based on old-fashioned quill pen lettering that developed as a distinct style in the 17th and 18th centuries, when the art of letter writing evolved into a thing of beauty as well as a communication. Modern script forms pay homage to these early free-flowing, elegant, handwritten communications.

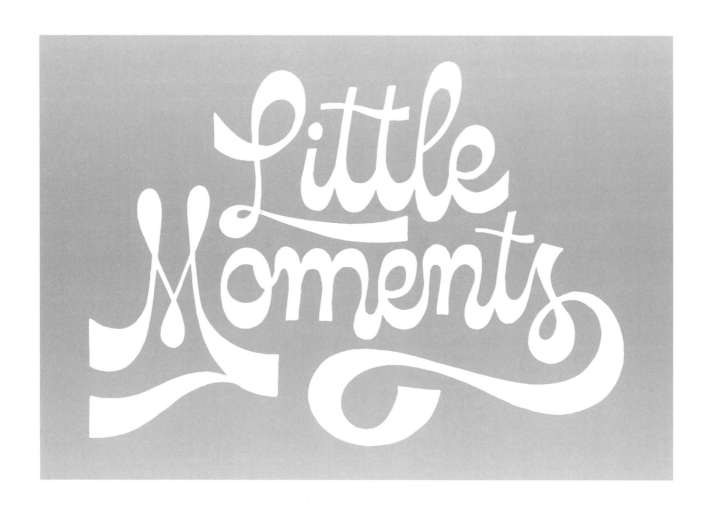

Beautiful

Love

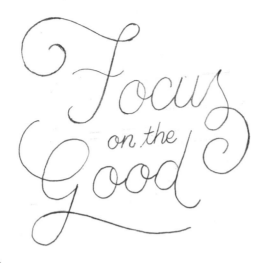

1. Start by drawing your slanted guidelines—this way, you'll be able to keep your letters at the same angle. Sketch your layout beginning with a simple script first.

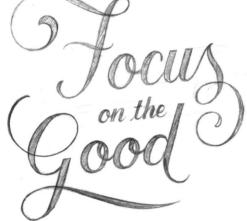

2. Add weight to your letters by going over the words again. Adjust your letter sizes if necessary. Add swashes to fill empty spaces and make your layout more interesting and elegant.

3. Look over the composition again and check letter spacing, spellings, etc. Add drop shadows and any other elements that you think would suit the overall composition.

4. Finish your project by drawing it up in ink using tracing paper and a light box, or inking directly on top of the lettering. Alternatively, finish it in color, either digitally or using other mediums such as watercolor or poster paint. →

Ornate

The first—and probably finest—examples of ornate lettering were made for medieval prayer books and bibles where the first letter of a chapter was elaborately decorated. More recently, ornate lettering has been used on posters, perhaps most eye-catchingly on Belle Époque and art nouveau billboards in 19th-century Paris. Now ornate lettering is being rediscovered as an art form and beautiful examples are not hard to find, especially in children's books.

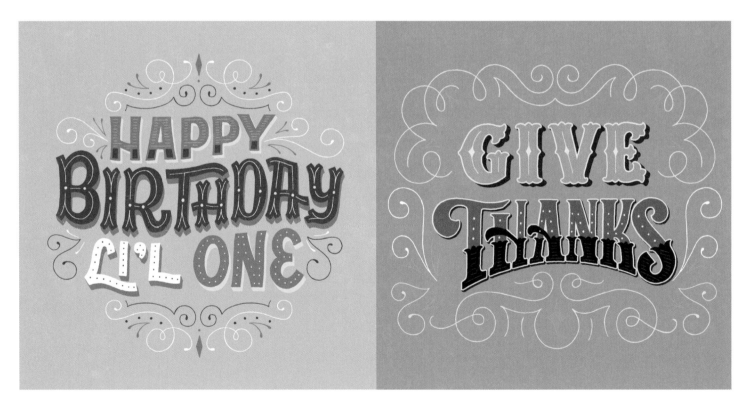

MOM

DREAM

1. This time draw the words on curved lines. Because ornate letters are highly ornamented the composition can easily become over complicated, so there are times it's best to combine a mix of simple serif or sans-serif lettering, as I have done here.

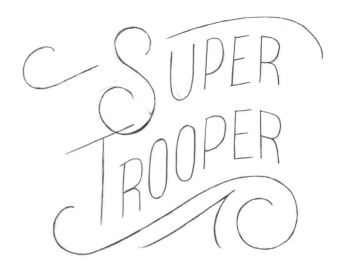

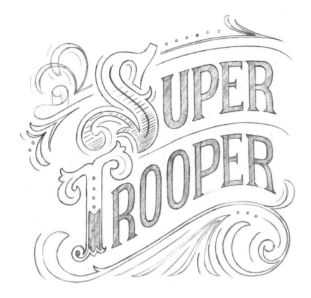

2. Add weight to your letters by going over the words again. Add swashes and filigrees for a super-stylized look.

3. Look over the composition again and check letter spacing, spellings, etc. Then, begin working up the details on the two main letters—a more elaborate inline, intricate outline, drop shadows, plus any other elements you think work with the style.

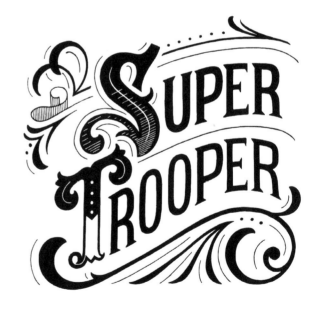

4. Finish your project by drawing it up in ink using tracing paper and a light box, or inking directly on top of the lettering. Alternatively, finish it in color, either digitally or using other mediums such as watercolor or poster paint.

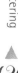

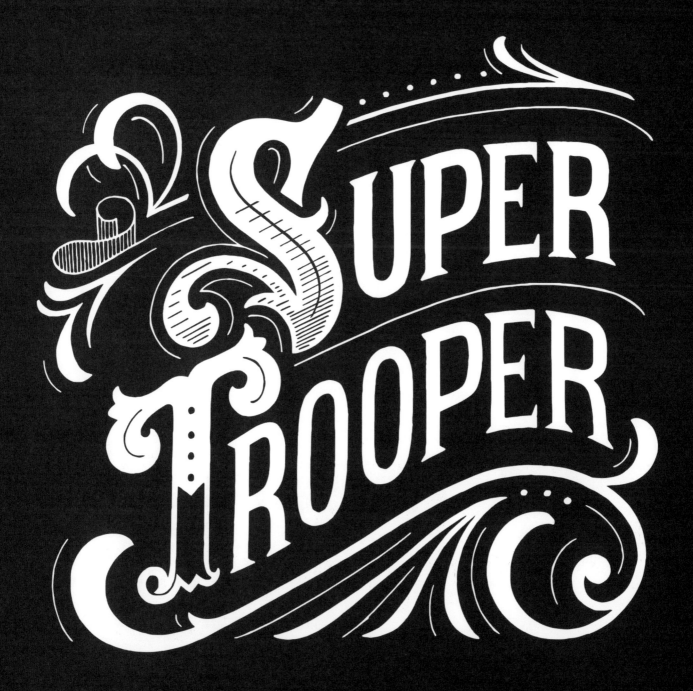

Dimensional

As a display typeface for impact and shout-out-loud "look at me!" nothing beats dimensional lettering. This style is associated with the fairground and other popular attractions, but perhaps became really fashionable when the so-called Space Race of the late 1950s and 1960s made all things science fact and science fiction hugely attractive. Like ornate lettering, it is a headline style, not a text style and works best when it's brief and to the point.

DO DOWN

CURVE

VANISH

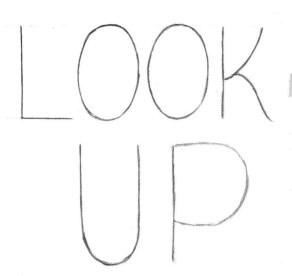

1. As with any composition, begin by sketching your phrase. Try different angles to get the most impact for your slogan. Don't forget to use your tools— ruler, triangle or T square to get the perspective absolutely perfect.

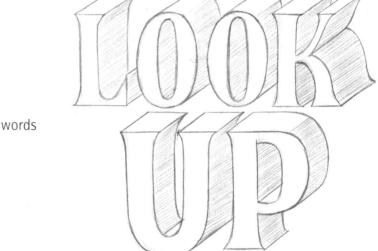

2. Add weight to the letters by going over the words again. Check letter spacing, spelling, etc.

3. Using your ruler (or triangle and T square), begin working on the structure of your dimensions. Decide on the angle of projection and draw it out. Add in the drop shadows and the rest of the dimensional framework as needed.

4. Finish your project by drawing it up in ink using tracing paper and a light box, or inking directly on top of the lettering. Alternatively, finish it in color, either digitally or using other mediums such as watercolor or poster paint.

Blackletter

Black Letter and Gothic lettering are collective references to the dense, carefully crafted, early printed forms of text. The earliest books and pamphlets were printed in Black Letter and while its popularity widely died out—it is really quite hard to read—it remained current in Germanic countries until well into the 20th century. These days this style of lettering conjures up medieval attributes and fantasies and has widely been adopted by the heavy metal music scene to reflect their take on life and style.

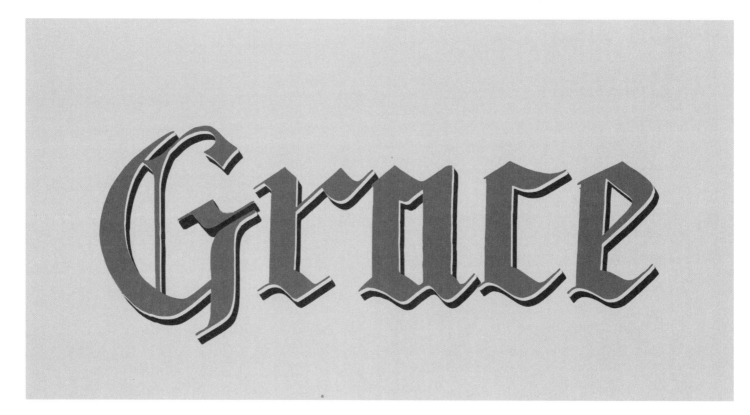

Once upon a Time

Rise Up

TRIBE

1. Drawing Black Letter can be tricky if you aren't familiar with their specific details, and two parallel lines make a good start. Ideally, you should use a parallel pen or rollerball pen, otherwise try using two pencils taped together so they draw simultaneous parallel lines. Position your pencils at an angle, about 30–45 degrees, and start sketching your words.

2. Add weight to your letters by going over the words again. Check letter spacing, spelling, etc. Black Letter is known for its dramatic thick and thin strokes, so pay particular attention to those.

3. Add elements like swashes, icons, and drop shadows to give your composition more interest. Check for any inconsistencies in sizes and adjust as needed.

4. Finish your project by drawing it up in ink using tracing paper and a light box, or inking directly on top of the lettering. Alternatively, finish it in color, either digitally or using other mediums such as watercolor or poster paint.

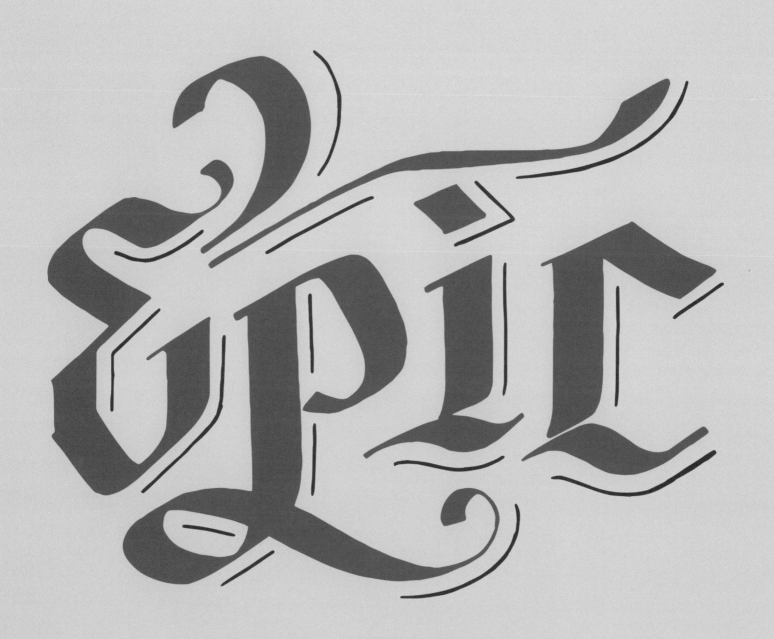

Illustrative

This style of lettering, where the letters themselves help to convey the message of the words, has a venerable pedigree in children's illustrated fiction. With improving printing techniques in the 19th and 20th centuries, illustrative lettering became popular, especially for book jackets. As advertising became ever more prevalent in the 20th century, illustrative lettering really took hold and lots of products are now indivisible from their lettering. Many company logos provide fine examples of illustrative lettering.

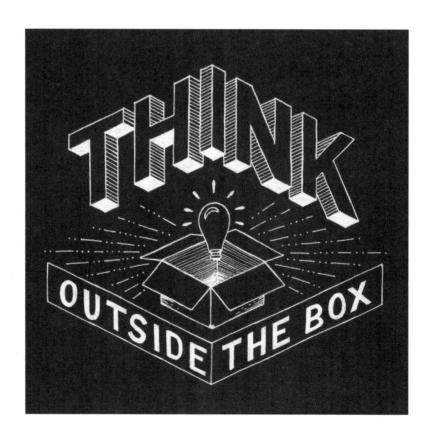

1. Work on some thumbnails for an initial sketch and combined illustration. This will help you plan where to place the words, the illustrations, and other elements in the best alignment for your composition.

2. Add weight to the letters by going over the words and remember to add details to your illustrations as well. Then, add styling to your letters, add a serif, change the letter size and consider making some irregularly shaped letters!

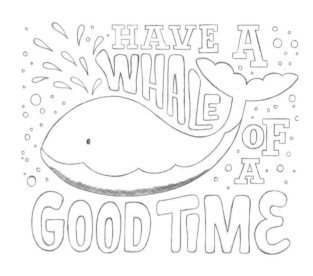

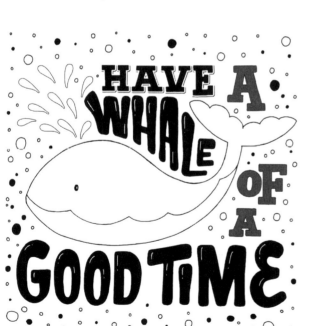

3. Assess and revise your layout again. Check spelling, letter spacing, and look out for negative spaces that need to be fixed. Add inlines, drop shadows, and outlines. Think about what to do with the background

4. Finish your project by drawing it up in ink using tracing paper and a light box, or inking directly on top of the lettering. Alternatively, finish it in color, either digitally or using other mediums such as watercolor or poster paint.

HAVE A WHALE OF A GOOD TIME

Chalk Lettering

This style evolved in the early days of commercialism when storekeepers wrote out pitches for their goods on dry chalkboards. It rapidly became obvious that the more attractively lettered signs had more eye-appeal and so more effort went into creating the look. Today many bars and restaurants go to considerable lengths to present their menus and advertising with chalk-style lettering. It has become an art form in itself and is considerably more sophisticated than its apparently simple appearance.

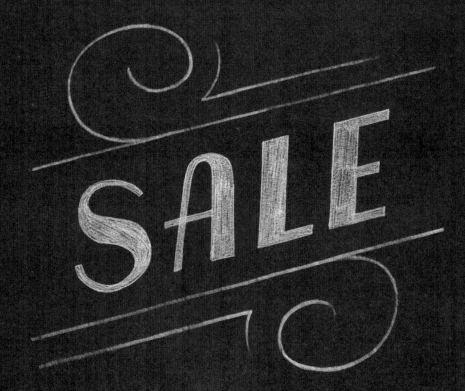

CHALK IT ALL UP

Work
- IN -
Progress

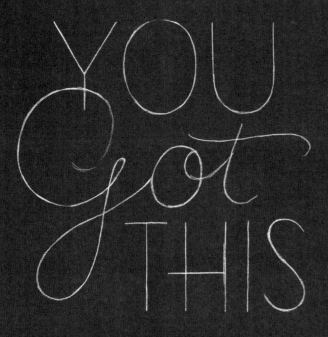

1. For this project you will need a chalkboard, chalk, or chalkboard marker. On the chalkboard, lightly sketch your phrase. Adjust words and sizing in order to fill the space required.

2. Add weight to your letters by going over the words again. Clean your layout and erase any unnecessary sketches left.

3. Draw over your sketch and fill in the spaces. At this stage you can add details like inlines, drop shadows and/or shadow lines for a more dynamic look.

YOU GOT THIS

Drop Cap

These are as old as printed text but also, like decorated letters, have a pedigree that stretches back to medieval times and early bibles, prayer books, and instructive texts. Drop caps (short for dropped capitals) started in the earliest days of lettering at a time when words were written so tightly together that they could be hard to read. The drop cap was an ideal way of signaling a new paragraph when text was densely spaced. These days the drop cap is still a widely used convention but has become a visual way to embellish the text without actual illustration.

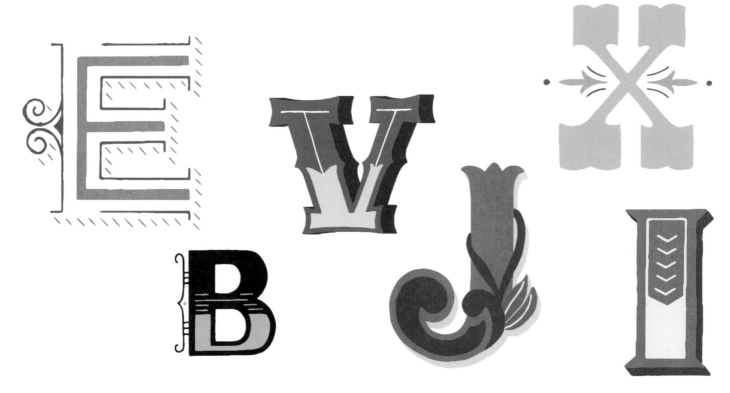

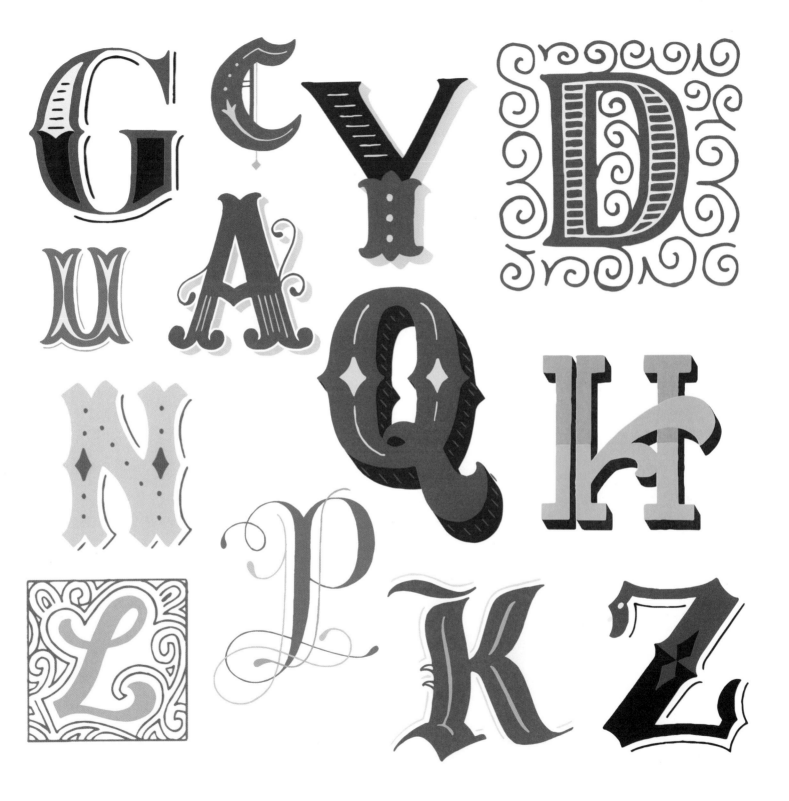

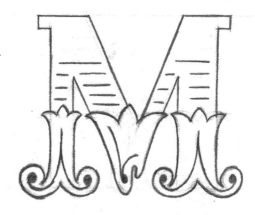

1. Choose your letter, then lightly sketch it in sans-serif style before adding weight by going over it again.

2. Now choose a style. Add serifs to your strokes. Examine the letter and check for areas where you can add finer, more elaborate details. Turn your simple serifs into more intricate endings like Tuscan or Gothic serifs.

3. Exaggerate the shapes and experiment further. Add inlines, outlines, or even swashes if you want. Consider also adding drop shadows or drop lines.

4. Finish your project by drawing it up in ink using tracing paper and a light box, or inking directly on top of the lettering. Alternatively, finish it in color, either digitally or using other mediums such as watercolor or poster paint.

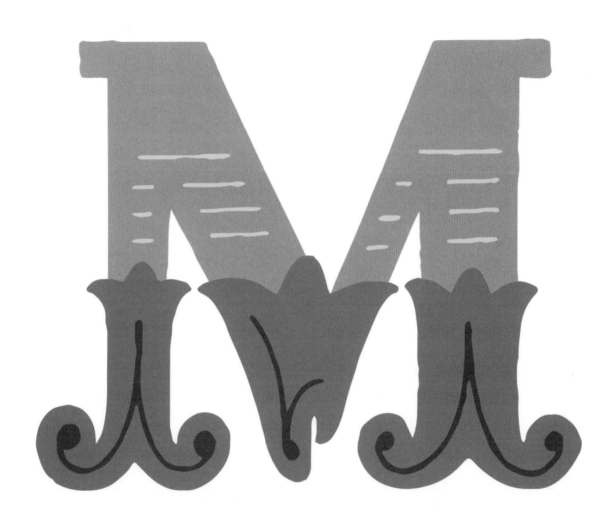

Combining Styles

The technique of mixing different lettering styles arose in the last couple of hundred years along with the growth of commercialism and advertising. A clever mix of styles draws the eye and calls attention to lettering, often in a subconscious way—absolutely ideal for adverts. The real trick is to combine the right juxtaposition of lettering for maximum effect; when badly used it completely confuses the message.

STOP ACTING SO SMALL YOU ARE THE UNIVERSE IN ECSTATIC MOTION

RUMI

LIVE LAUGH LOVE

For this exercise I chose bracketed serif, sans-serif, hairline serif, and decorative serifs with detailed inline for a really dynamic look. I wanted to highlight the word BETTER and because it's in the center, I want it simple and bright to draw the eyes first. Because of the limited square composition, I chose an arc shape for the words, SOMETHING and NOTHING so that I can fit both words in comfortably. However, NOTHING is shorter than SOMETHING, so to compensate for the letter spacing, I decided to make the style a little ornamental to take up the space. The word SOMETHING doesn't need to take up so much space, so a bracketed serif is more fitting.

 The result is simple yet it complements the serif on NOTHING. The words IS and THAN don't need as much attention, so I gave them only a hairline serif—but slanted so the eyes will move around the page. Finally, I added some filigrees, so there isn't any negative space in the middle of the composition.

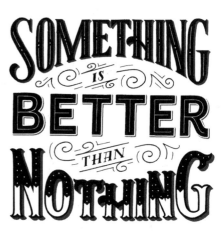

SOMETHING IS BETTER THAN NOTHING

Tiny
-BUT-
MIGHTY

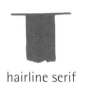
hairline serif

bracketed serif

slab serif

slab-bracketed serif

Well done, you've made it this far! And you already know the rules so now, it's time to break them! In this section, you will be provided with different lettering style examples and exercises. Use this area to explore and work freely. Repetitive work helps you improve so make use of this space to create more. If you need extra papers, ordinary printer paper works just fine. Are you ready?

gothic serifs

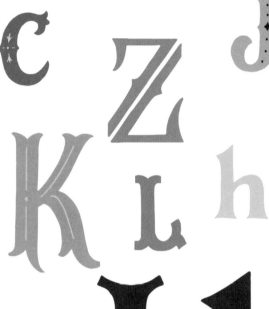

tuscan serifs

cupped serif

old style serif

glyphic serif

Style your Serifs

Earlier in this book you learned how to draw letters, particularly sans-serif and serifs. We used the three basic styles to draw contrasting letters. However, there are lots of other serif styles you can play with in order to change the styling of your letters. Above are some of the most common serifs. Study each of them. Then, incorporate them into your lettering.

B

Apexes and Vertices

The letter A's apex and letter V's vertex are very interesting to play with. You can manipulate these points and turn them into something more special. Draw it straight, round, pointed, or cupped—your choice. Explore some serif styles and incorporate them on the apexes and vertices. Study the changes and practice to find more.

A

Swash It

Leg, arm, tail. What do these parts have in common? They are attached to one part of the letter and are free on another. Which means, you are free to SWASH IT! By definition, a swash is an exaggerated serif, tail, terminal, or even entry and exit strokes! Study the examples below, then experiment and work on your letters. But be careful, too much of everything is not good, so make sure your flourishes are not overly done.

Crazy Crossbars

Instead of drawing it straight, there's a variety of way you can draw the crossbar (or x-bars) of the letters A and H. You can try a curve, slant, twisted, decorated crossbar and that small change can drastically improve your letter.

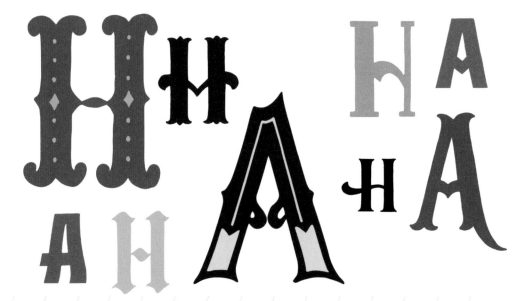

Filigree

A filigree is an ornament with fine, delicate details. In lettering, there are various ways to make one, depending on the skills of the artist. Filigree can be anything from simple, curve lines up to a more elaborate and intricate artwork. Use them as you see fit and to your taste. Try adding it to a swash, to fill in some negative spaces, to create borders, and much, much more!

Shadows and Dimensions

Adding drop shadows and shadow lines to your lettering completely changes the overall appearance of your artwork and lettering.

Start simply and learn the basics of shadowing first. Understand where the light source is. Shadows are cast opposite the light source; so, when your light source is on the upper right, your shadow is cast to the lower left. Use your ruler to project your drop shadows and draw parallel lines as guides if you can't do it by eye yet.

When you have mastered the basic shadowing technique, you can notch it up and move on to more complex shadowing and dimensional projection to create even more expressive artwork.

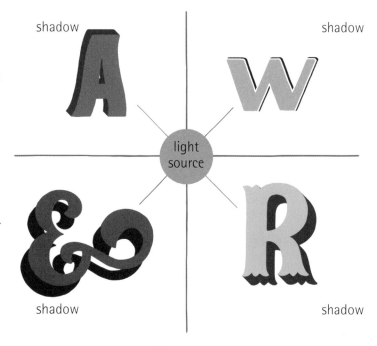

shadow shadow

light source

shadow shadow

dimensional projection

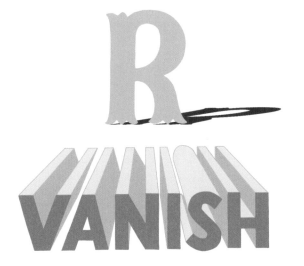

In the following exercise, we will try these two basic shadowing techniques.

The first one is by projecting the image to render the shadow at a particular angle. Draw parallel lines from all the main points of the letter as a guide, and then connect the lines to recreate your letter in shadow; this in turn becomes your drop shadow.

In the second technique, instead of drawing parallel lines, use a single reference to draw lines along all main points of the letter. Use these guides to cast the shadows.

light
source

Draw on a Path

Don't be restricted to drawing letters on a straight line. Try drawing a word along a slanted path, curved path, wavy path, and so on. If you are having difficulty drawing them, use guides. In this exercise, you're going to need a compass and a ruler. Similar to the examples provided, you can draw in a single path or multiple paths. Study them as well as the guides provided and then try it on your own.

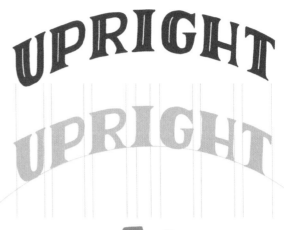

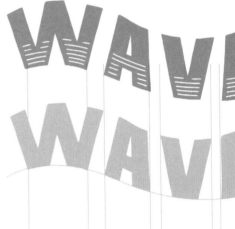

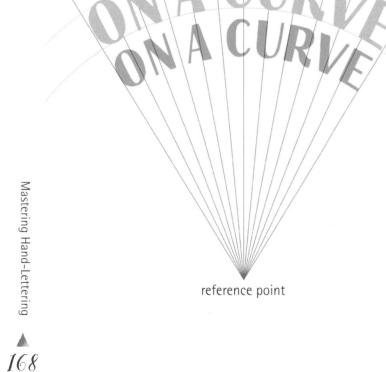

reference point

Draw in a Shape

Lettering inside a shape is another playful way of rendering your letters. The contained space forces you to manipulate the letters to fit inside the shape, often with exciting results.

Take a look at the examples below. There are times when your letters will fill your entire shape (Let's Make Magic) and sometimes, not (Cloud). In those cases, find ways to fill the empty spaces so the shape is still visible. Maybe color it in or fill it with other shapes or symbols.

Practice drawing in a shape by tracing one of the examples here. This way, you'll get to familiarize yourself with the unconventional shapes of your letters when you are working in a very limited space. Then, draw your own shape and hand-letter something in it.

DEDICATION

To my dear husband, Kris, thank you so much for your never-ending love and support. Also to my children—Scieszka, Elysia, and Alphonse—for challenging and inspiring me every day and making me a better person. I am what I am because you are always there for me. I love you so much!